Comfort Fairies
coloring book

Dedicated to my parents, who always believed in me through thick and thin.

Copyright © 2019 Rebekah Davis.
All rights reserved.
No part of this publication may be reproduced without written permission of the author.

ISBN: 978-1-79480-868-3

Welcome

I hope this book finds you well – I really do. I hope your circumstances are merciful, your challenges bearable, and your heartaches fleeting. May this book uplift your spirits in times of need, reminding you that The Universe is always speaking to us through symbols found in nature. The raven that passed you on your morning walk, the moth at your window, the rainbow overhead, the sudden gust of wind… those were Comfort Fairies with messages for you. This book contains each fairy's story of growth, but don't forget to listen closely for any specific advice meant just for you. This book can be referenced when an animal, insect, plant or weather change seems to be trying to get your attention, or with an oracle card reading. In whatever way you best communicate with Comfort Fairies, may they be your constant companions throughout life to remind you that even through the greatest struggles there is always solace to be found.

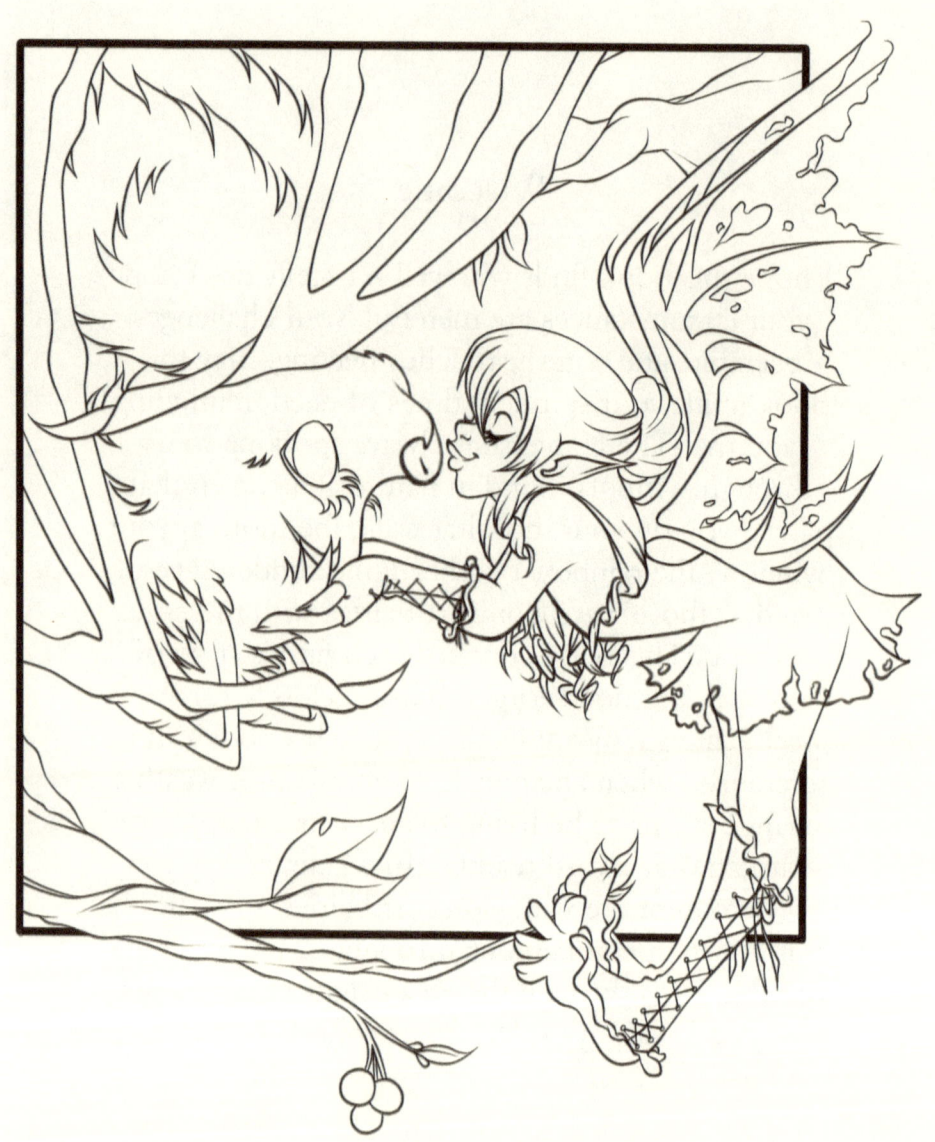

1

The Bat Fairy

Love of Mystery

The Unknown beckoned me and I stood intrigued but frozen. I planned, researched and prepared, but only gained fleeting confidence. I dreamed, wondered and questioned but no certainty came. Finally I answered the Unknown's call, one step at a time, and was delighted to find that there was so little to fear and so much to discover.

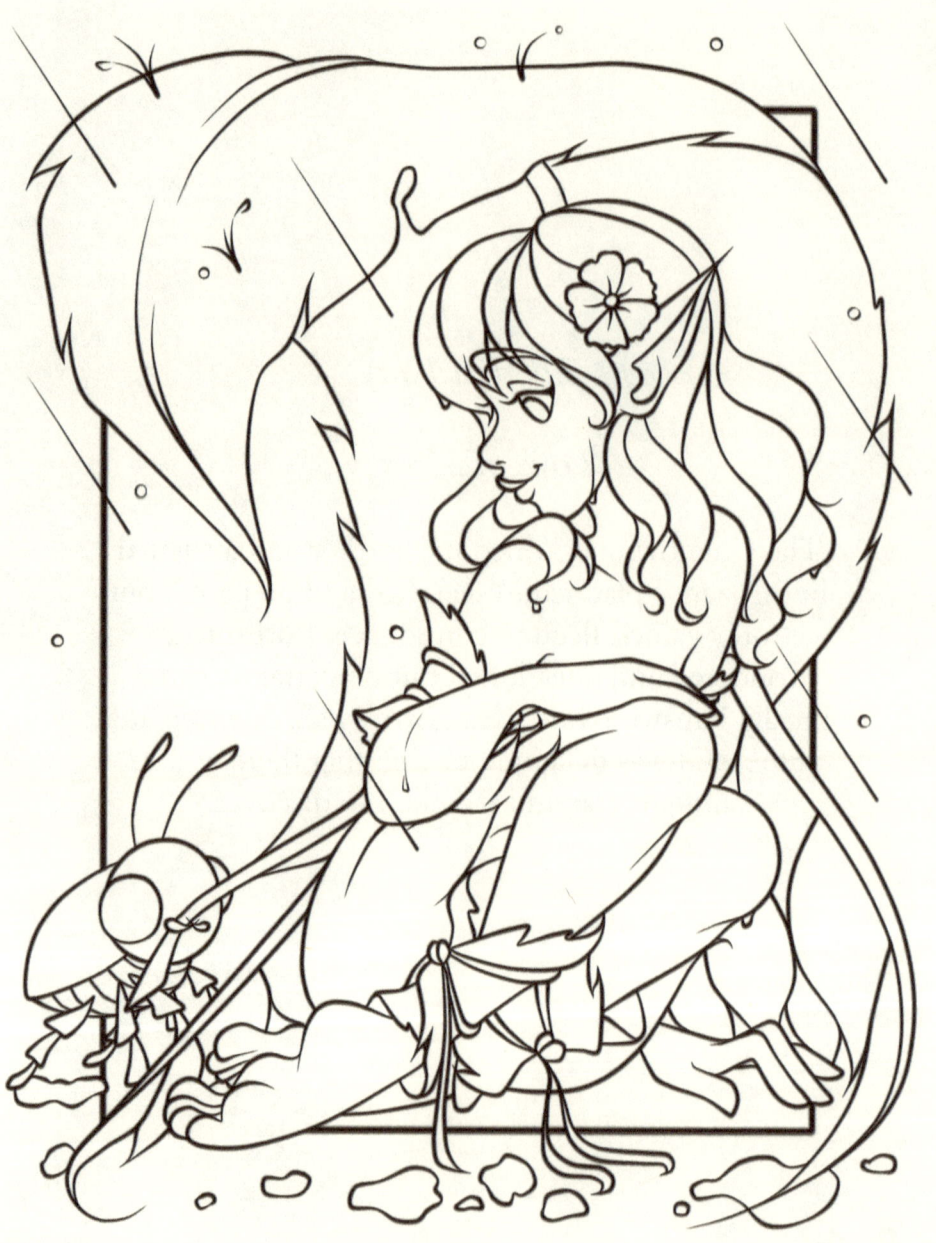

2

The Beetle Fairy

Gentle Strength

I sought strength in control, but only found mistrust.
I sought strength in violence, but only found fear.
Then in the midst of chaos I found a soft voice,
empathetic eyes and giving hands, and finally saw
Strength's true form.

3

The Blackberry Fairy

Unexpected Acts of Kindness

The thicket bade me come rest, and I responded, "You have nothing for me but thorns," but the night was cold and my bones were weary so I took shelter. When the sun arose I was greeted by blackberries and morning dew. Light finds me in my darkest hours through tender hearts and outstretched hands I didn't know were there.

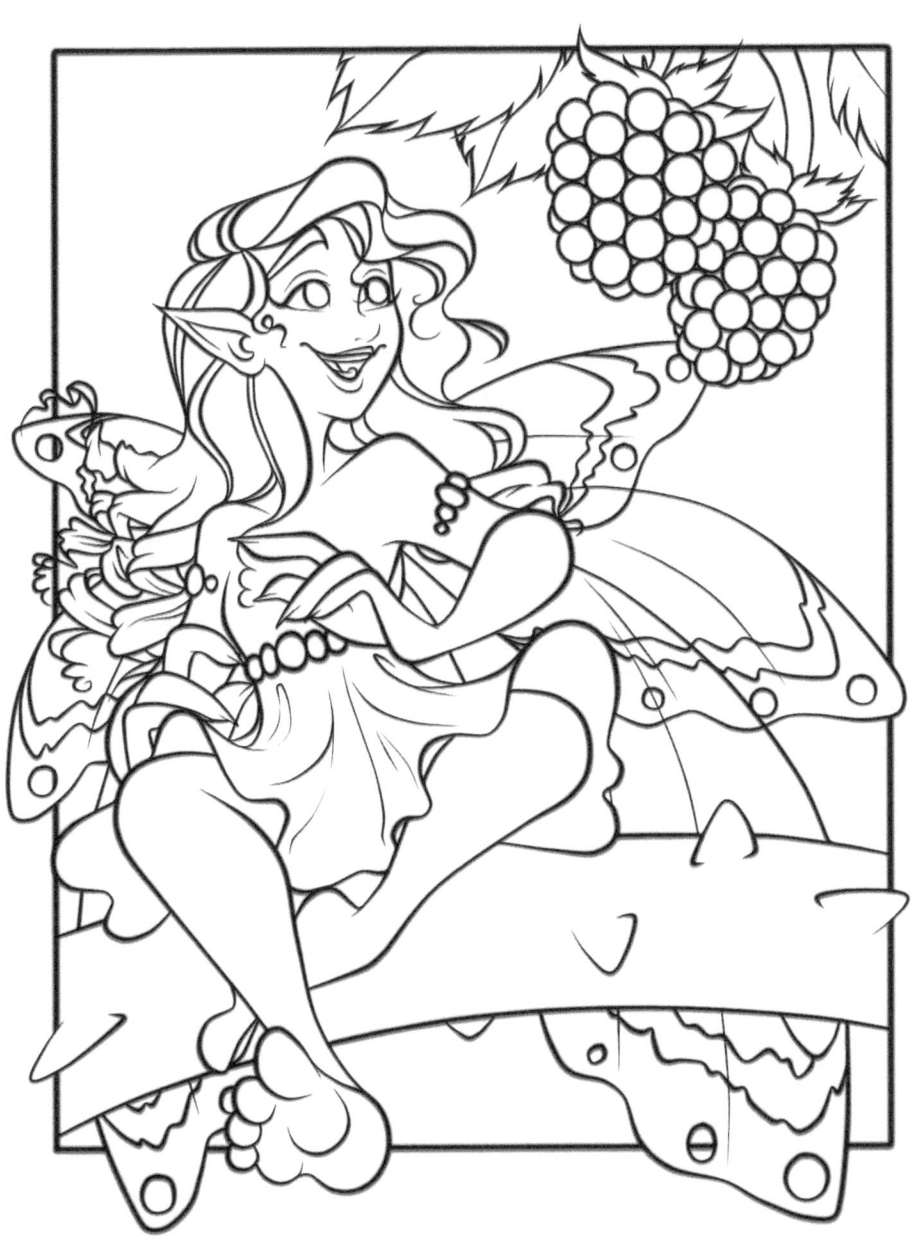

4

The Bumble Bee Fairy

Love of Life

I thought nothing of how gray my vision had become until my chest became lead and my will to fly vanished. I laid there, wondering what I had lost. I watched a bumblebee land on a flower, and the petals illuminated beneath its feet. My heart skipped at the sight, having forgotten the joy of color. Each blossom lit up with festive hues as the bumblebee hopped from one to another. It's then that I knew my world hadn't grown dull because it lacked magic, but that I had neglected to make my world magical.

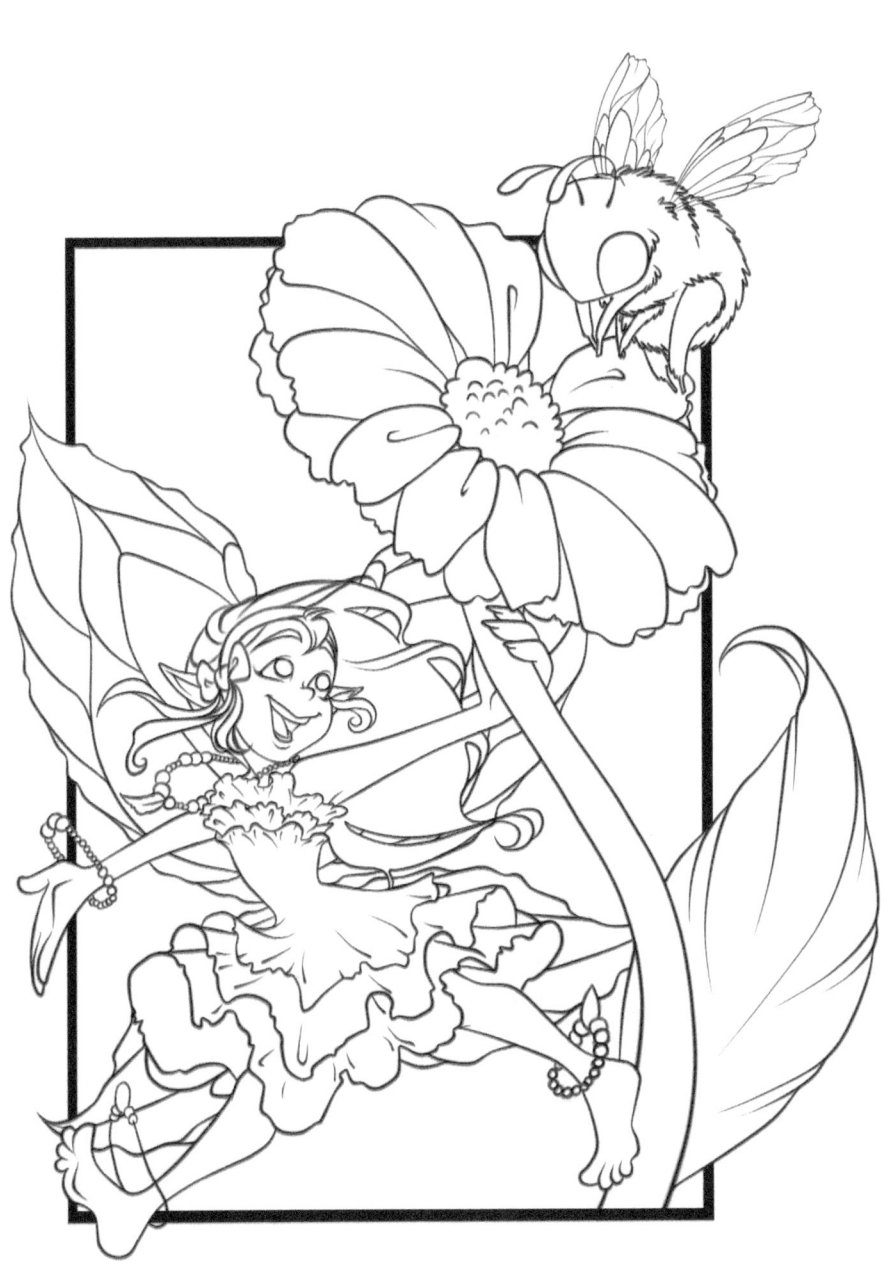

5

The Bunny Fairy

Self-Compassion

I forgive my mistakes without hesitation, knowing I'm learning just like everyone else. I'm patient with myself on my long journey, knowing I'll get to my destination some day just like everyone else. I wear my crown with pride, knowing I'm made of the same star dust as everyone else.

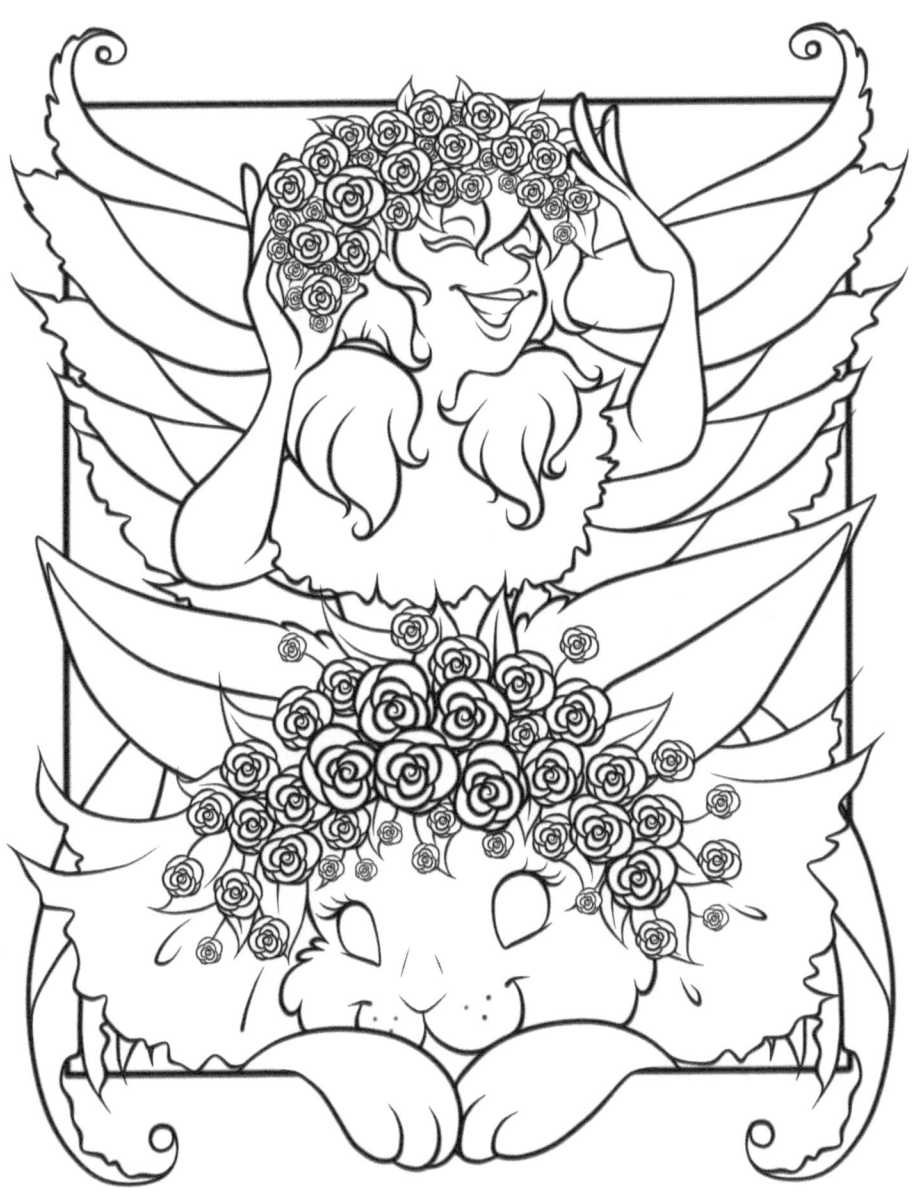

6

The Butterfly Fairy

Surrender to Grace

I knelt in exhausted frustration, wondering why my progress stopped so suddenly. How can I work so hard but get nowhere? "Perhaps it's time for you to rest in your cocoon too," a caterpillar suggested as he prepared his own. "I've done all I can, and now I'm letting Mother Nature take control. If I keep insisting I can transform all on my own, I never will." So I bowed my head and trusted The Universe to know what I don't and to do what I can't.

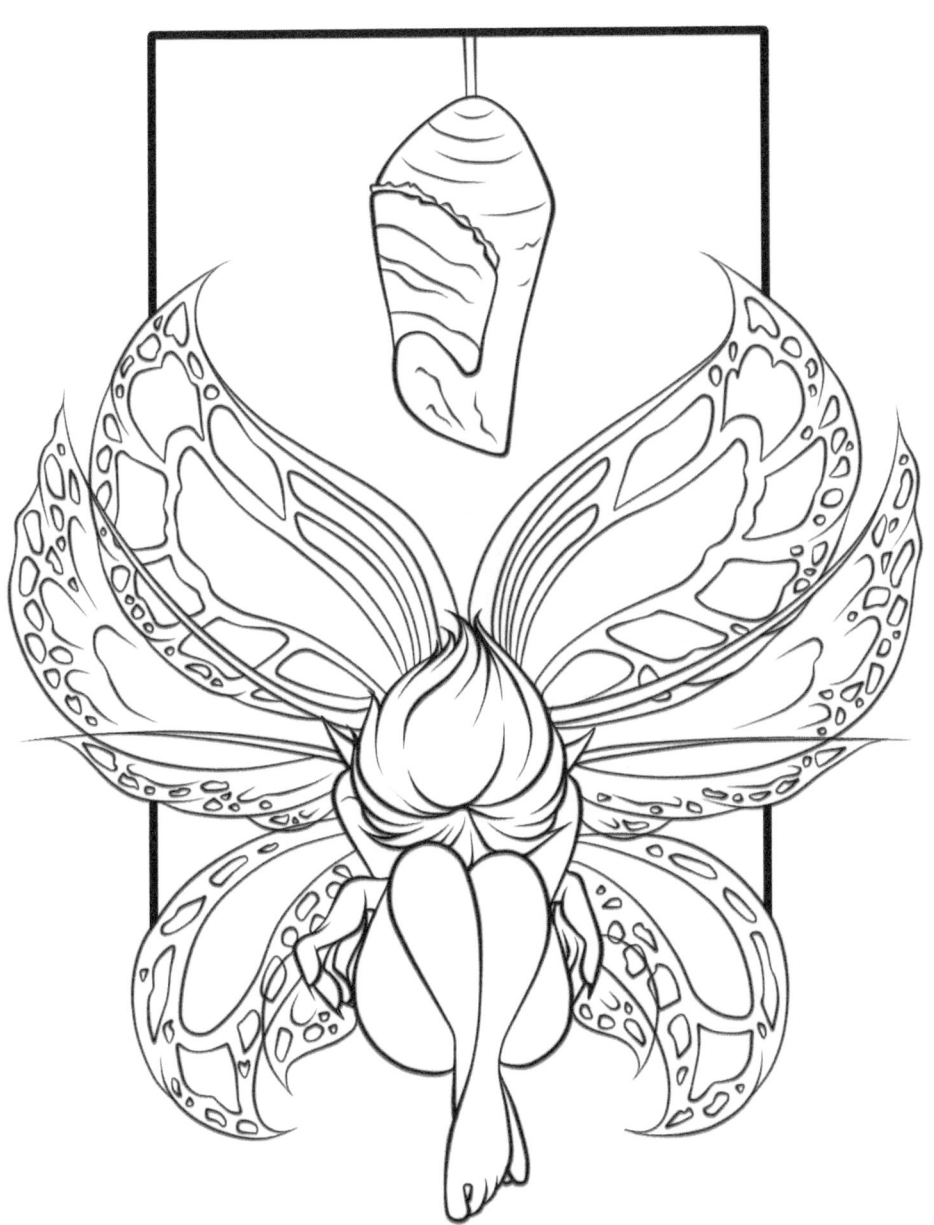

7

The Cloud Fairy

Look Closer

I looked and only saw what I wanted to see. The cloud whispered, "Look closer." I looked again and only saw what made sense to me. The cloud whispered, "Look closer." I looked again and saw distractions and assumptions. I looked past each one as I recognized them until I finally saw Truth.

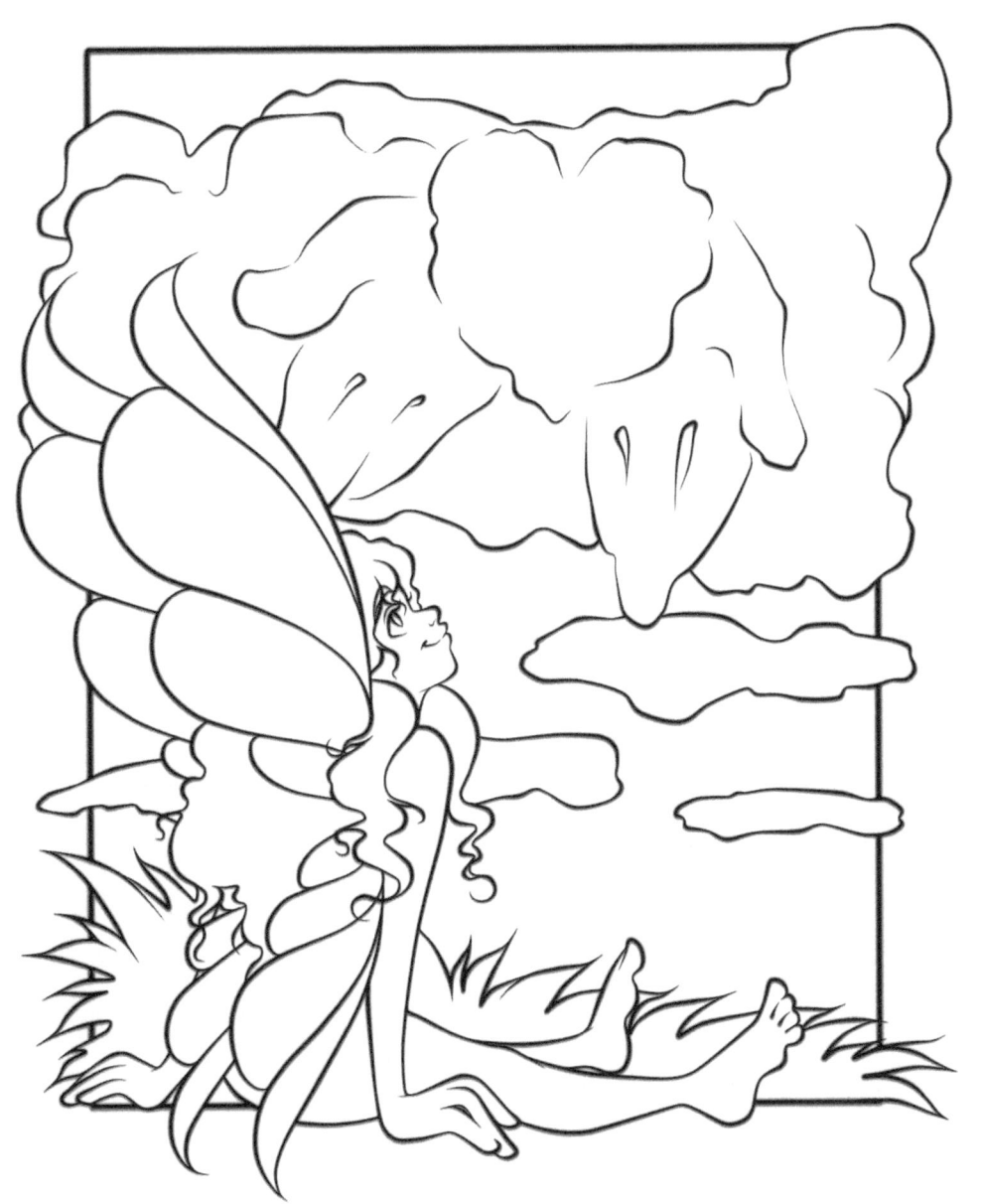

8

The Clover Fairy

Sweet Simplicity

My every moment was occupied by every good intention my imagination could fathom, and soon I found myself paralyzed by exhaustion. I thought myself inadequate until I dropped everything where I stood. Once my power and peace were reclaimed I picked up only what I valued most and carried on stronger than ever.

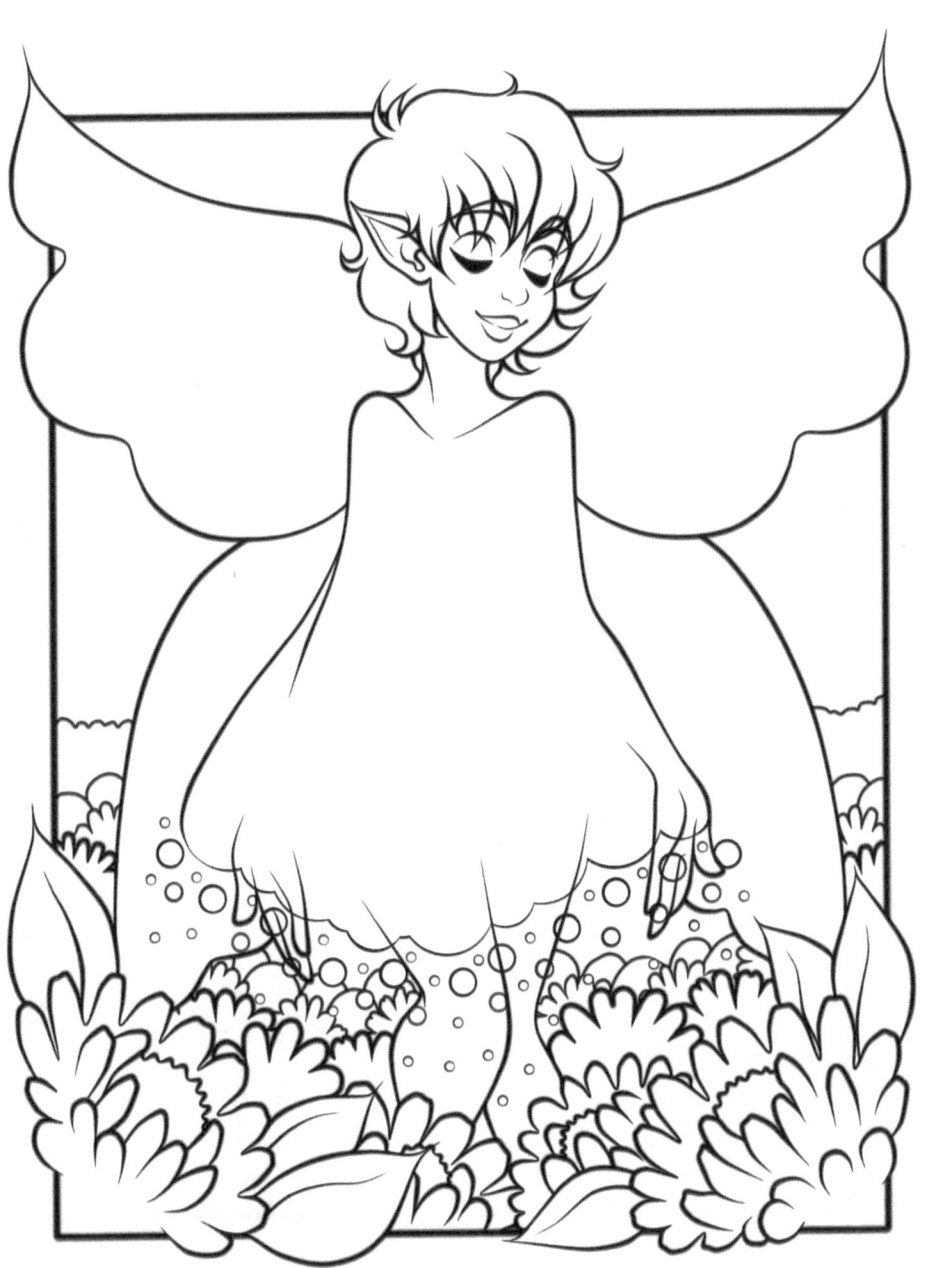

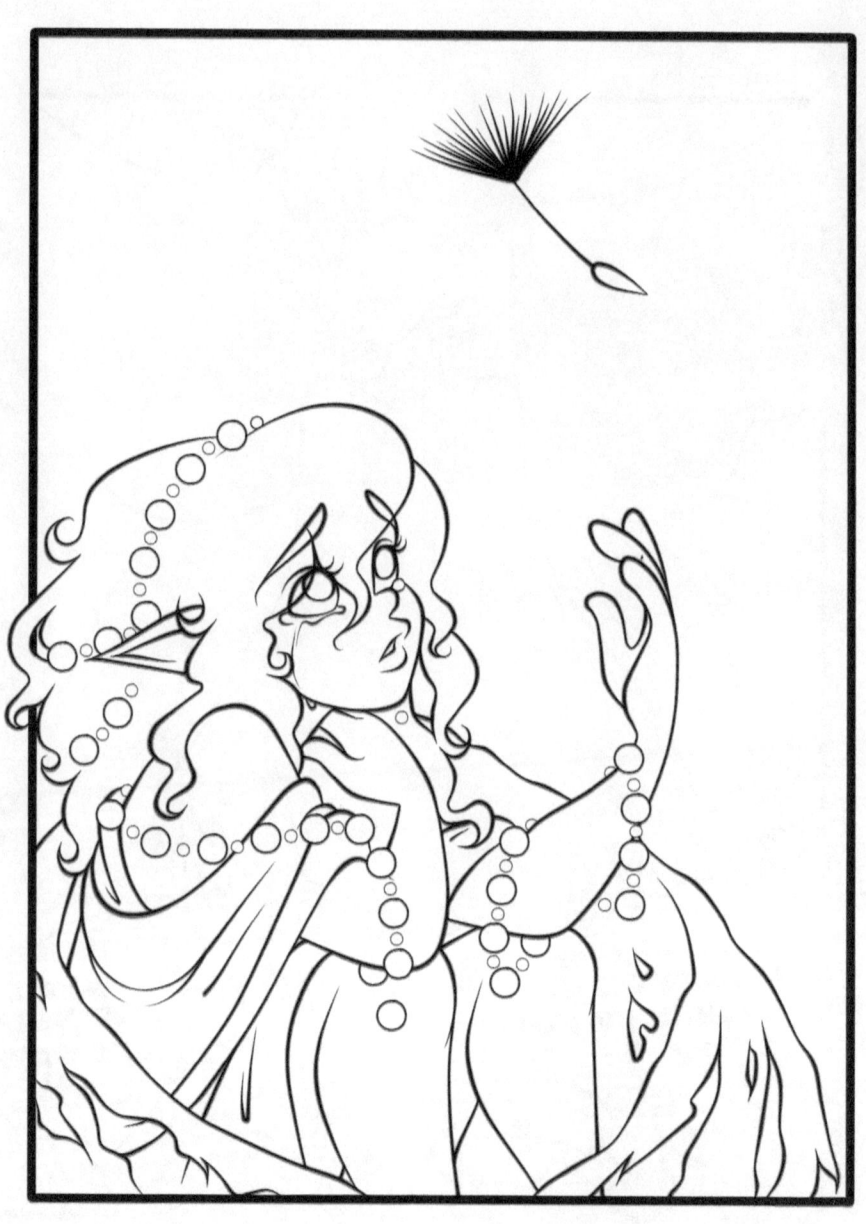

The Dandelion Fairy

Make a Wish

I fought the good fight and lost. My will was depleted, my faith dead, my light gone. A wish floated by and I almost let it pass, drained from defeat. Then I thought of all the wishes contained in that one wish, and all the magic awaiting in all of those wishes. I closed my eyes and sent my dreams off with the wish, trusting it to spread far and wide.

10

The Dragonfly Fairy

Self-Honesty

I had every reason to conceal My Truth until she vanished and took my identity with her. "Why did you leave me?" I asked the void. "You always told me I was wrong," My Truth answered back. Now when she speaks, whether I share her words with others or not, I tell her she is heard and loved. She returns my devotion with an inner strength I've never known before.

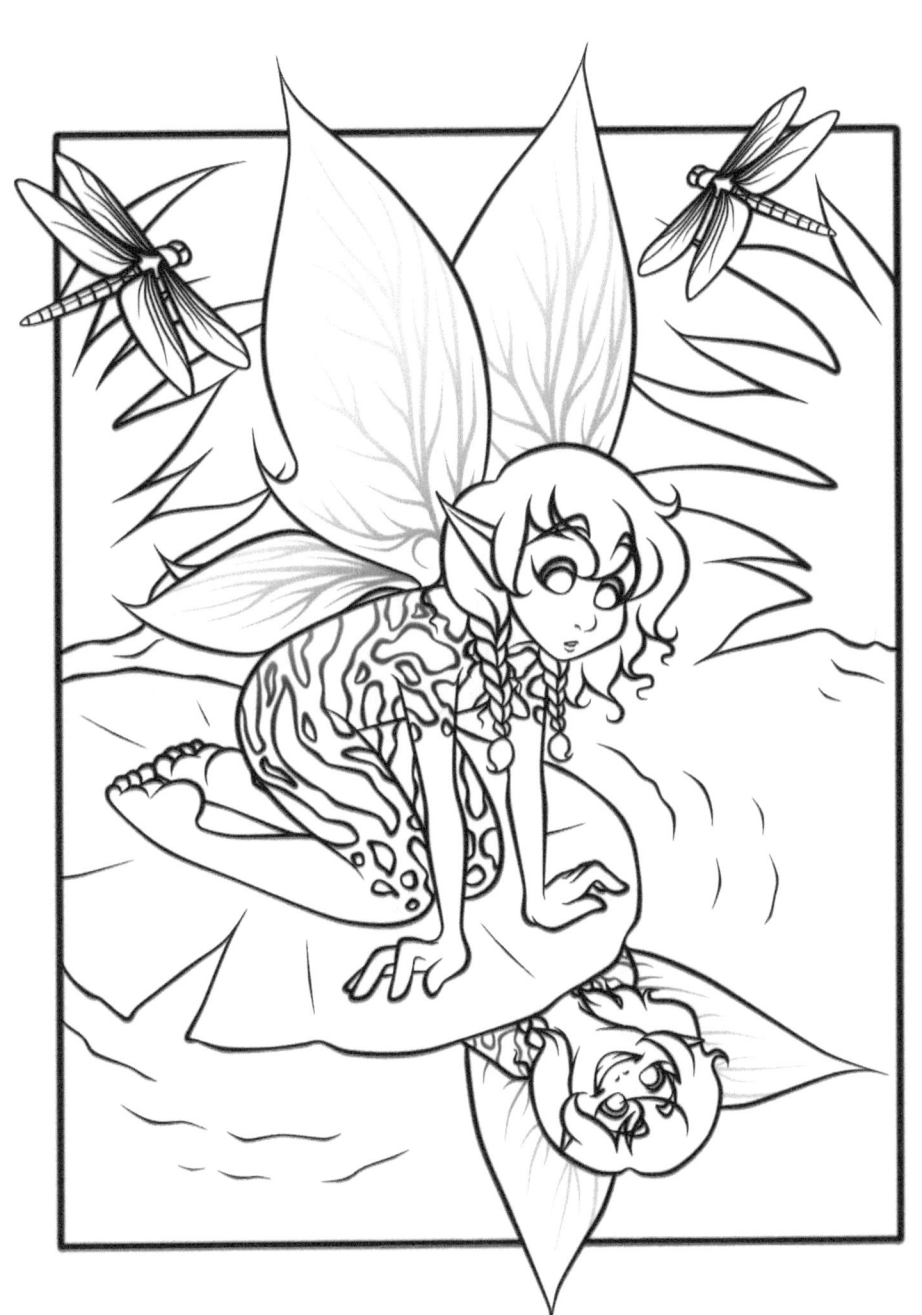

11

The Fawn Fairy

Childhood Wonder

My glimmering dreams lost their luster the day I learned of the sacrifice they demanded and the challenges they promised. I nearly dropped them where I stood when I saw a fawn envisioning the day he'll be big and strong, filled to the brim with childhood thrill so there was no room for fear. I then understood that my dreams were as beautiful as they'd ever been, I'd just been looking at them through the wrong eyes.

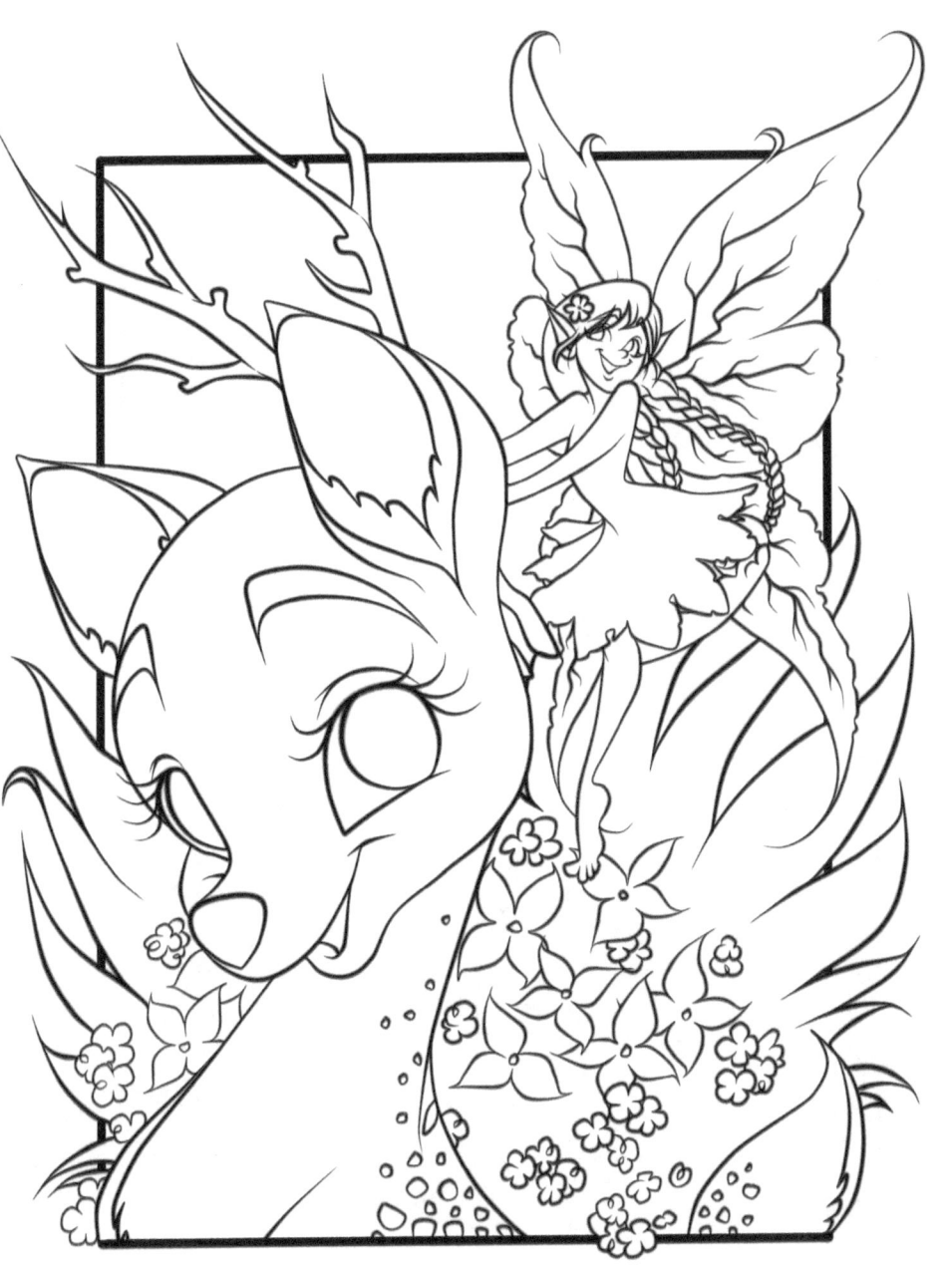

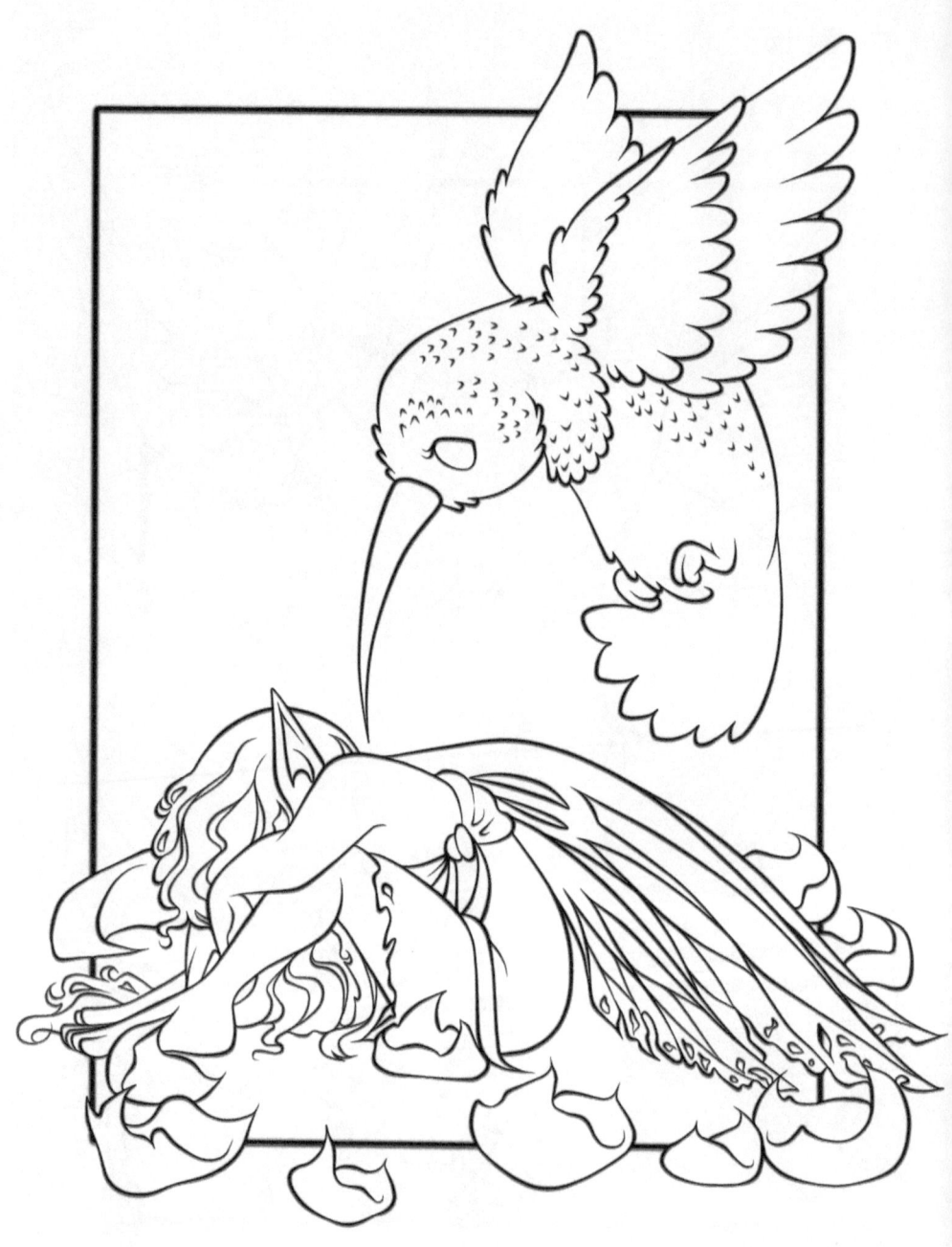

The Hummingbird Fairy

Eternal Love

I refused to let you go even though you were gone. A hummingbird saw me grieving and stayed by my side. She grew cold and hungry with me, and I finally realized what I was doing. "You can fly now, I'll be OK," I smiled through my tears. As she vanished into the sky I wished you happiness on your travels, knowing you're an eternal part of me.

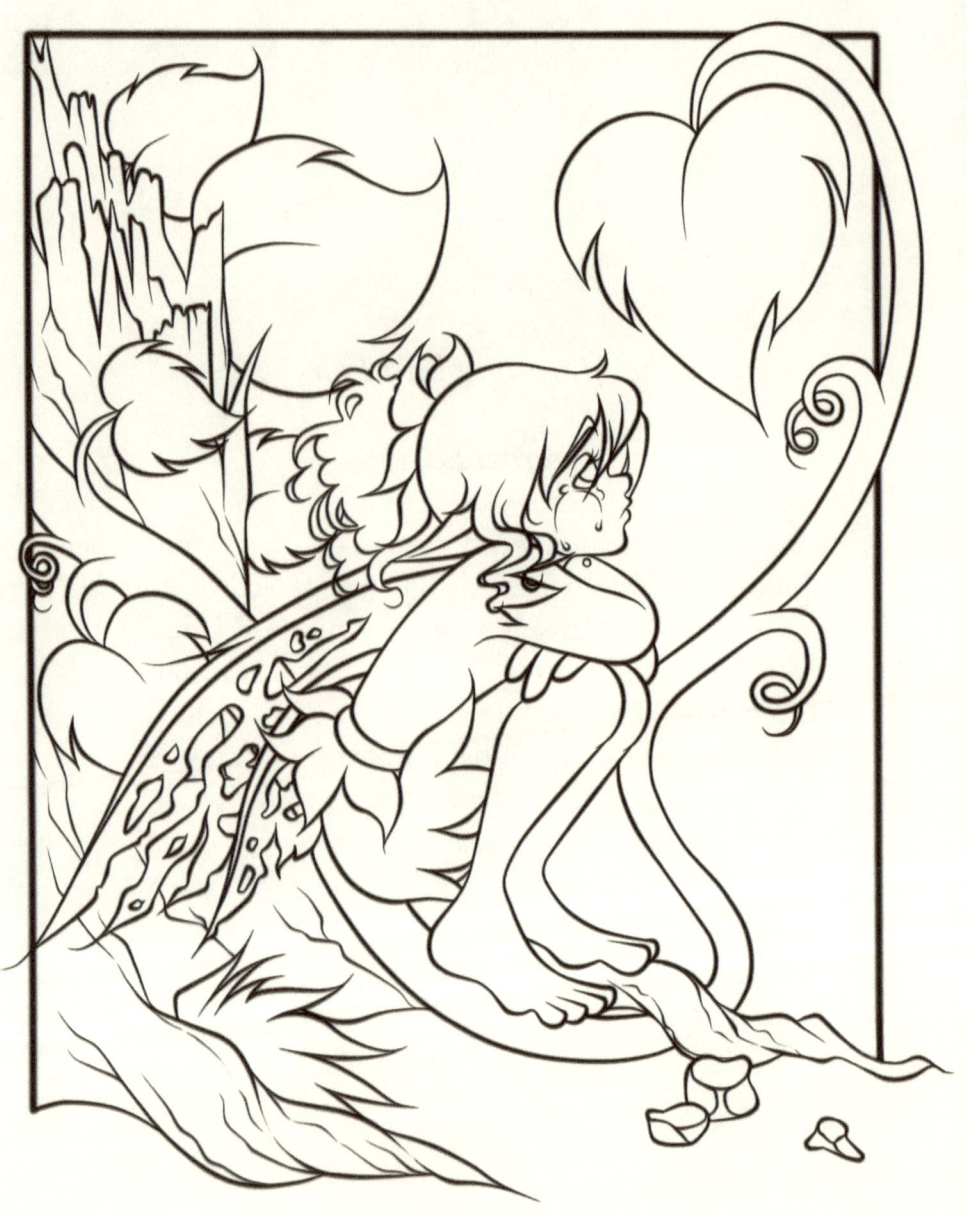

13

The Ivy Fairy

Joy In Sorrow

Ivy found me inconsolable, mourning the loss of what I wanted so dearly. "Feel your sorrow, but don't let it consume you," the Ivy nudged me softly. "Wrap yourself around the remains of your treasure. Thank it for what it brought you and for what losing it taught you." I then saw the moss growing, the grass sprouting and the bugs burrowing. I cradled my heartache but still kept my eyes open to the new beauty around me.

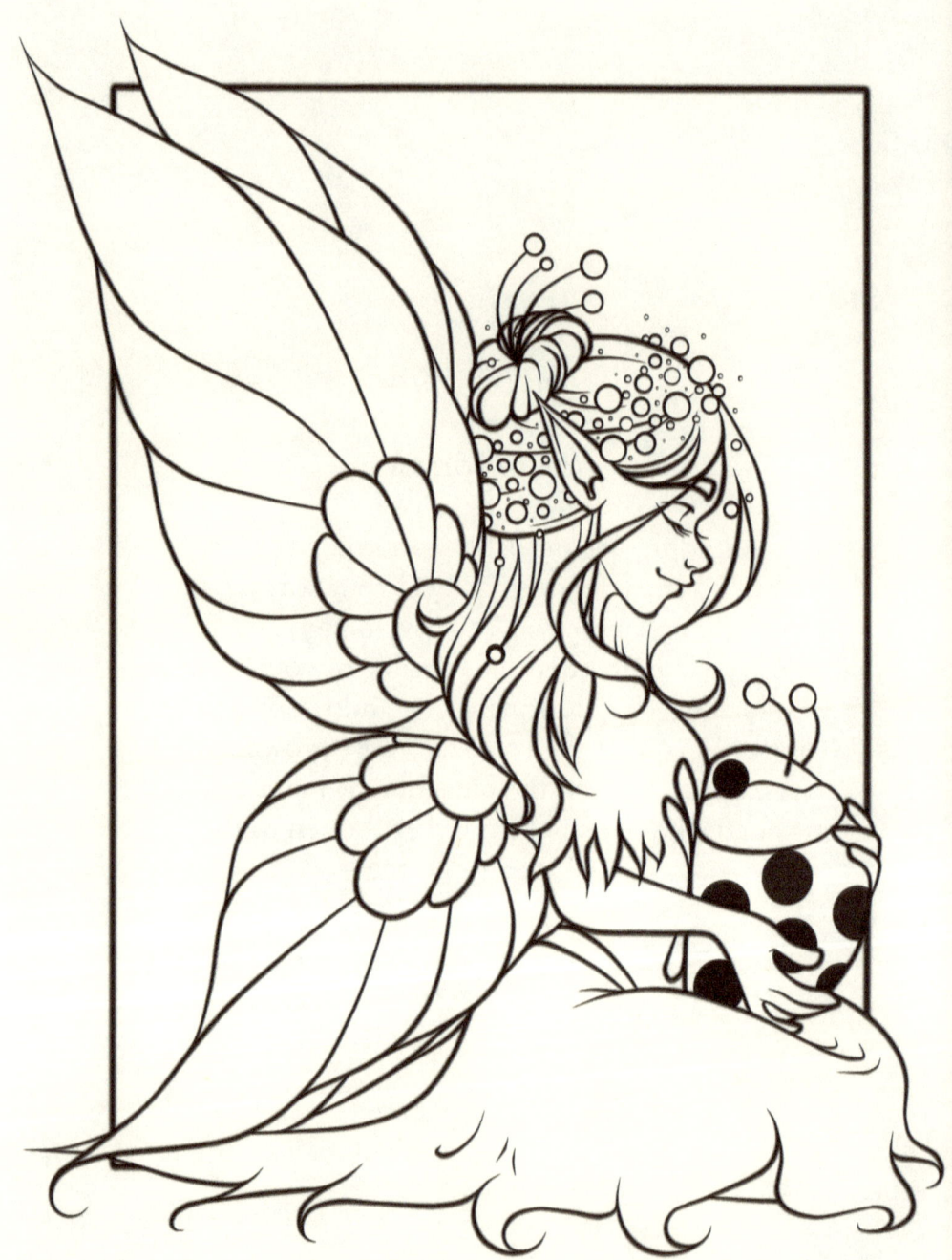

14

The Lady Bug Fairy

Trust Your Intuition

Logic had failed me repeatedly, leaving me feeling alone in my aspirations and wondering how I would ever achieve my goals with such limitations. As I knelt in exhausted defeat a ladybug crawled into my lap and reassured me that all good will is important to The Universe, and every desire to nurture any portion of this world grants us access to Eternal Wisdom, if only we take time to listen to the voice deep within us. "Like a Mother's Intuition?" I asked. "Exactly," she beamed.

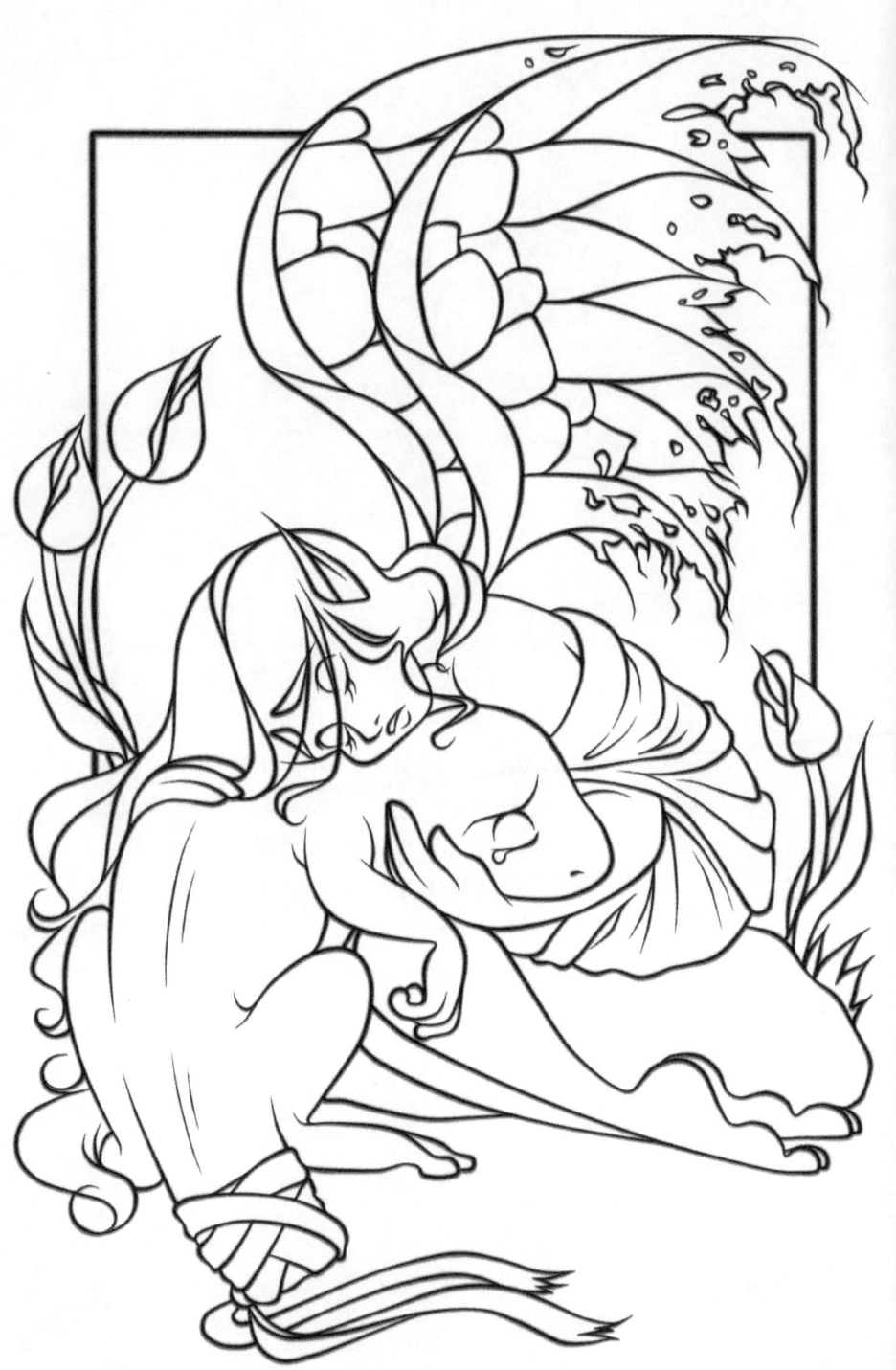

15

The Lizard Fairy

Patience in Healing

I glared at my tattered wings in fierce frustration, wondering why they refused to be as they once were. "You're sabotaging the healing process with your expectations of regaining what you lost," a wounded lizard approached me. "If you wish to be whole again, you must accept your new reality." I bowed my head, knowing he was right, and told my wings I would interfere with their transformation no longer. When my new form appeared I beheld a beauty I'd never before imagined.

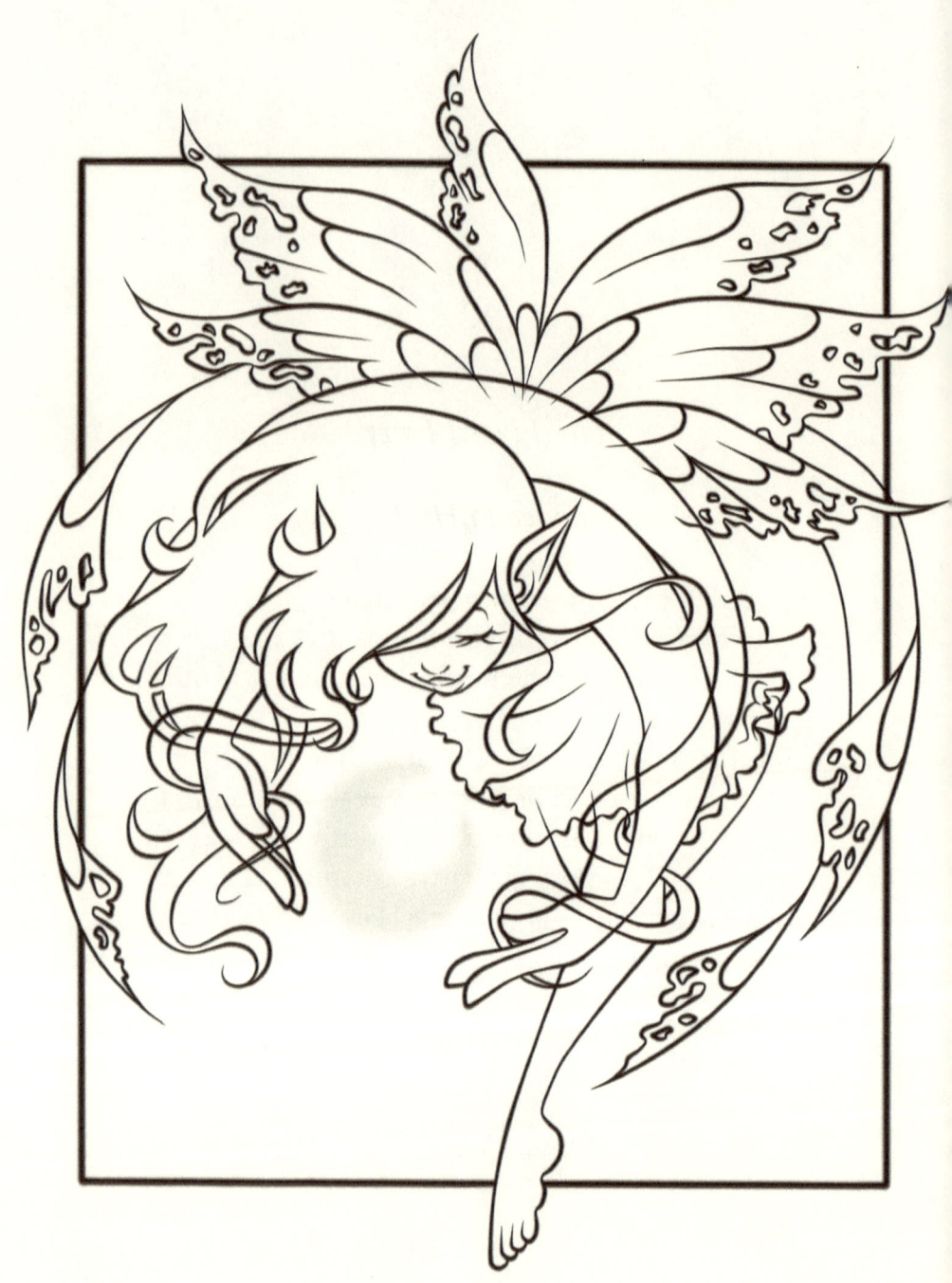

16

The Moonlight Fairy

Connection to a Higher Realm

I wandered aimlessly along, questioning who I was and why I was here. Fear flooded my chest, worried that I was an unwanted stranger. The moon shone bright upon me and whispered, "The Earth and Sky claim you just as they do me, for our souls were created by the same hands and are tied to the same realm." I felt her warmth through the cold night air and continued on, claiming my heritage and purpose.

The Morning Glory Fairy

Self-Forgiveness

I hid my face in shame from the oncoming sunrise, unworthy of its light despite all my efforts to fix my wrong. "Why have you closed yourself up? Don't you want to feel the warmth and thrill of the new day?" a Morning Glory asked as it began to wake. "I don't deserve it," I choked through my guilt. "I don't know who deserves what, but refusing to let light shine on you is refusing to share it with those around you," the flower yawned as it opened wide. "A closed heart can't reflect light." I imagined a world full of buds closed tight, never to bloom. Now that's a true shame. I took a deep breath and faced the morning sun, determined to brighten the world along with it.

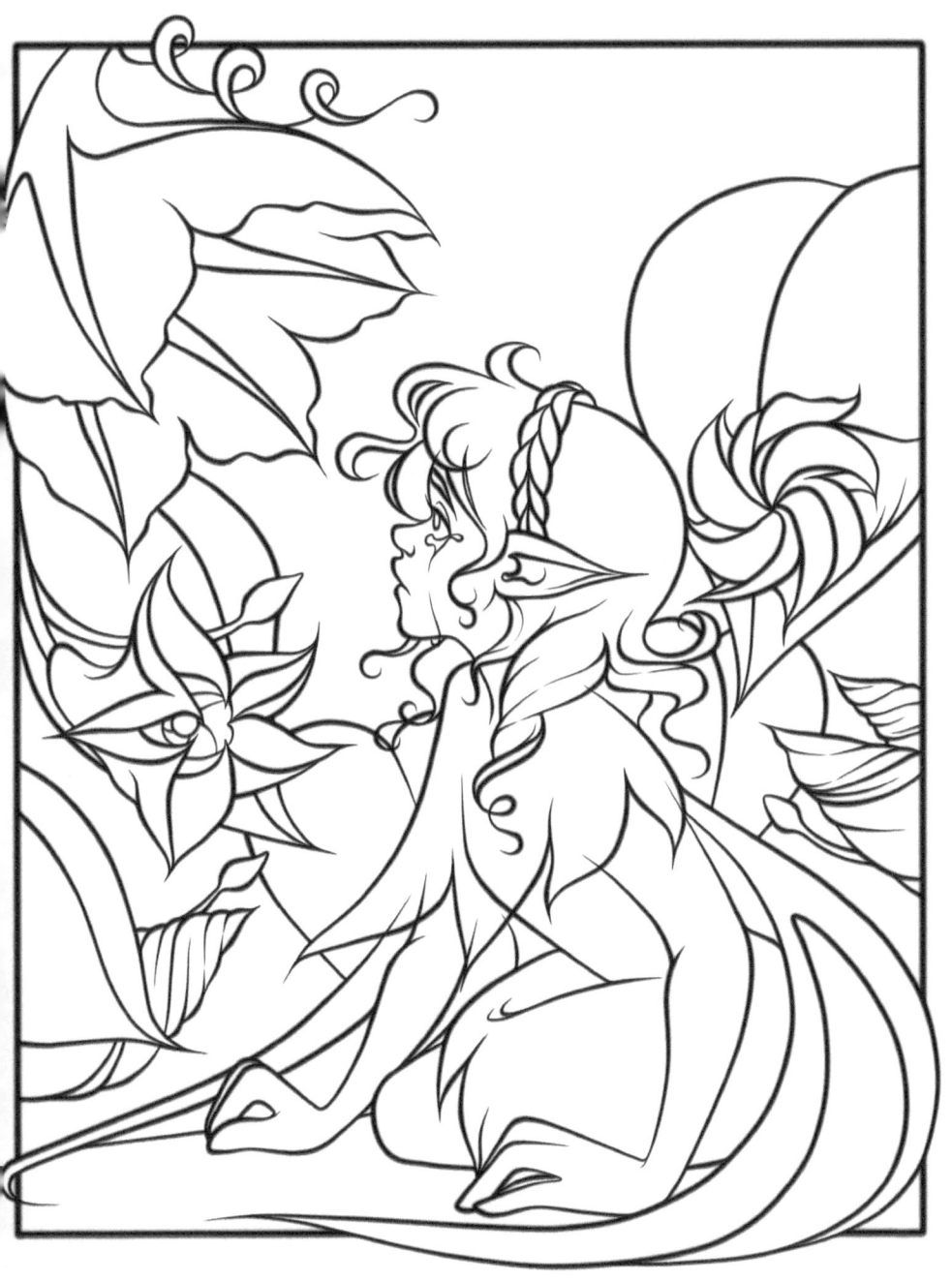

18

The Moth Fairy

See Hidden Magic

My sobs echoed over the cold swamp. My energy was gone and there wasn't a drop of magic to be found in this bleak wasteland, when something glimmered in the corner of my eye. Enchanted dust sparkled around moths as they fluttered by, the air grew serene with the music of crickets, and the night sky illuminated with the soft glow of fireflies. I felt my energy return, delighted at the magic hiding in plain sight all around me.

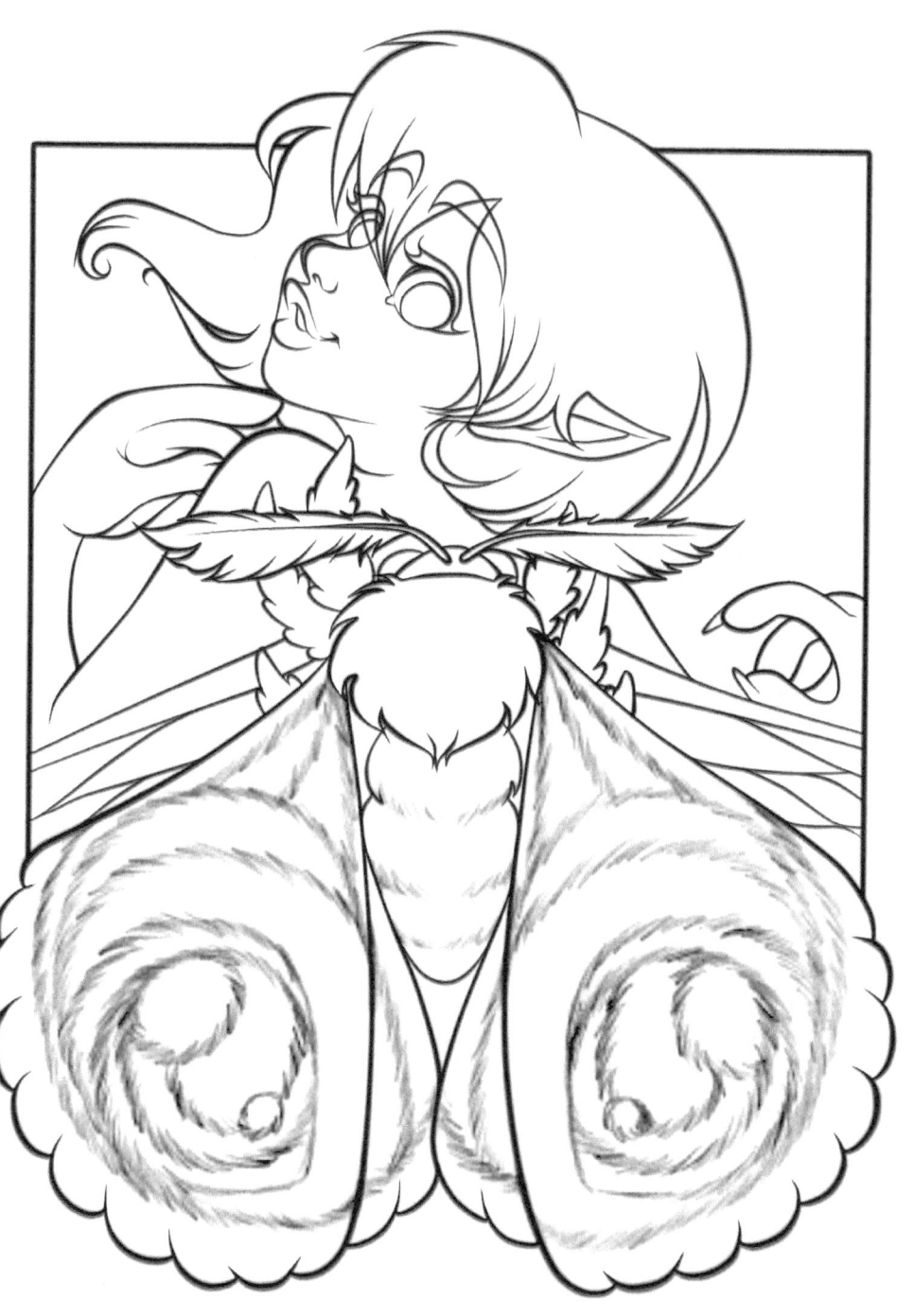

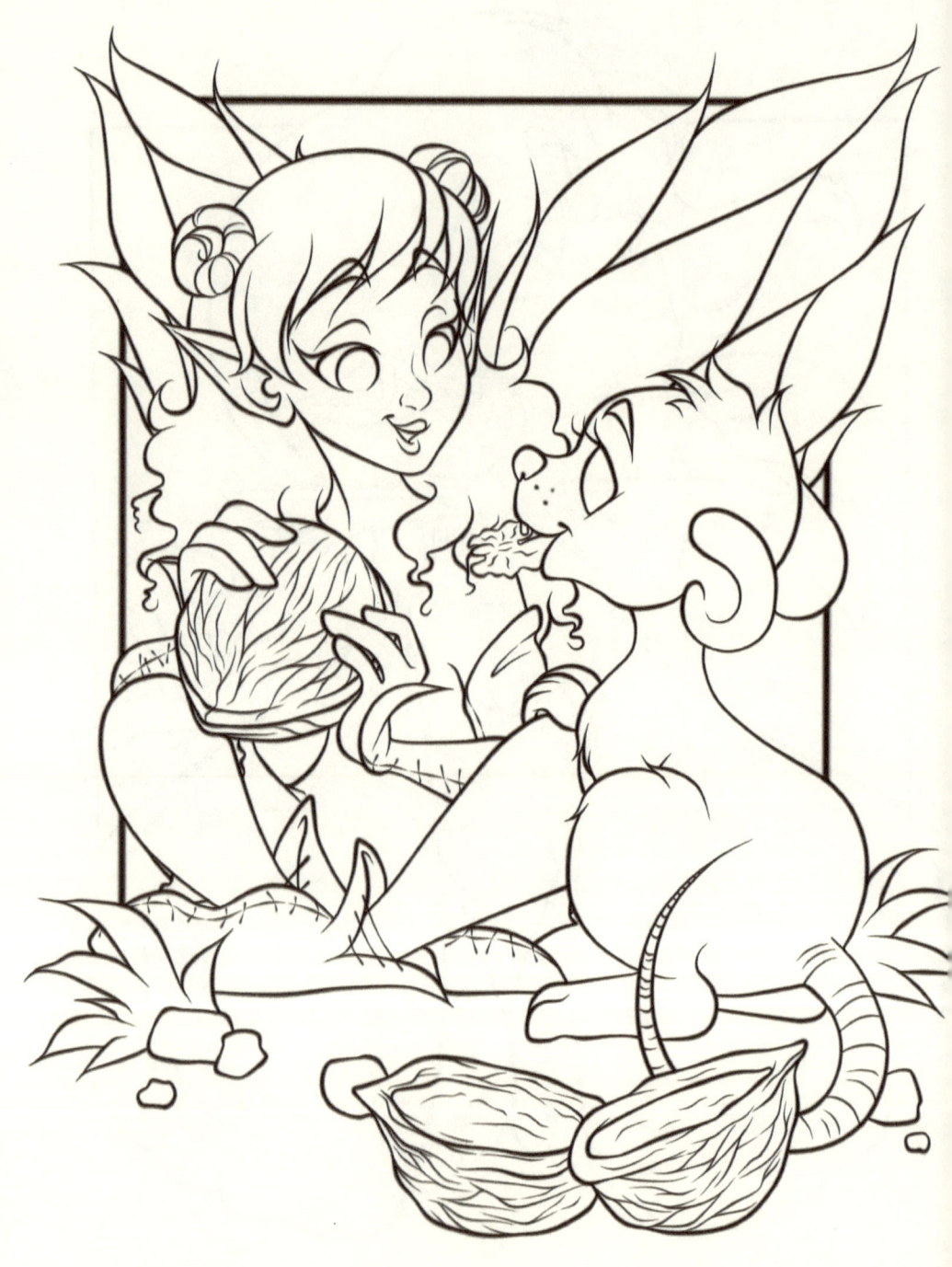

19

The Mouse Fairy

Strength of the Small

My life is full because of small things. The sun thinks nothing of shining, the flowers think nothing of blooming, the birds think nothing of singing, but to me they're invaluable. When I hesitate to contribute my seemingly-insignificant deeds I remember that to me it may only be a spark, but to someone else it may be the guiding light they've been waiting for.

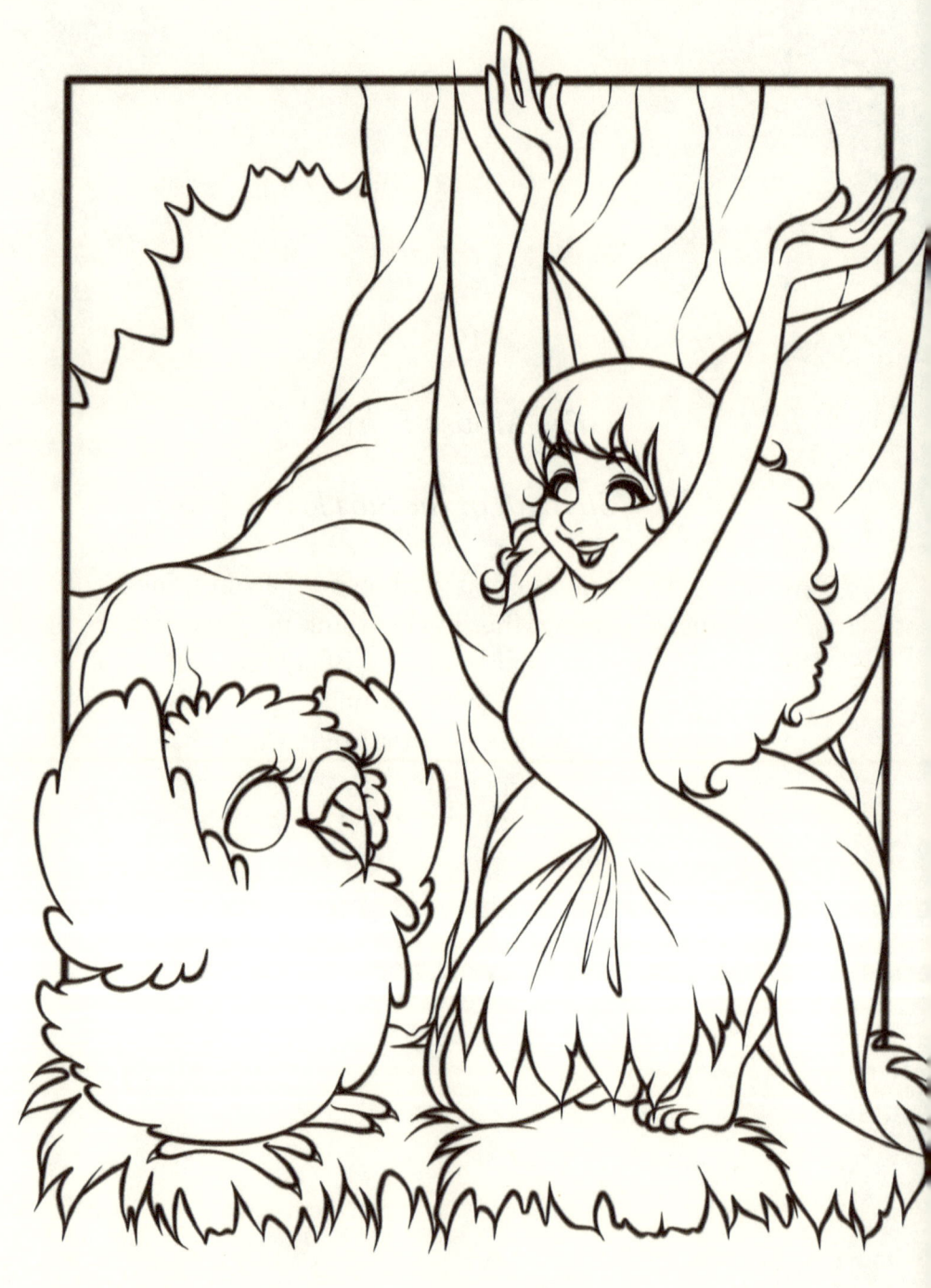

The Owl Fairy

Patience in Learning

The little owl must learn bit by bit, day by day, to become the symbol of wisdom he's meant to be. Even flying, as natural and common as it is for owls, must be practiced until it's mastered. When I'm frustrated with my slow progress, eager to fulfill my potential, I recall that nothing comes quick and easy to anyone but that doesn't make anyone any less destined to be great.

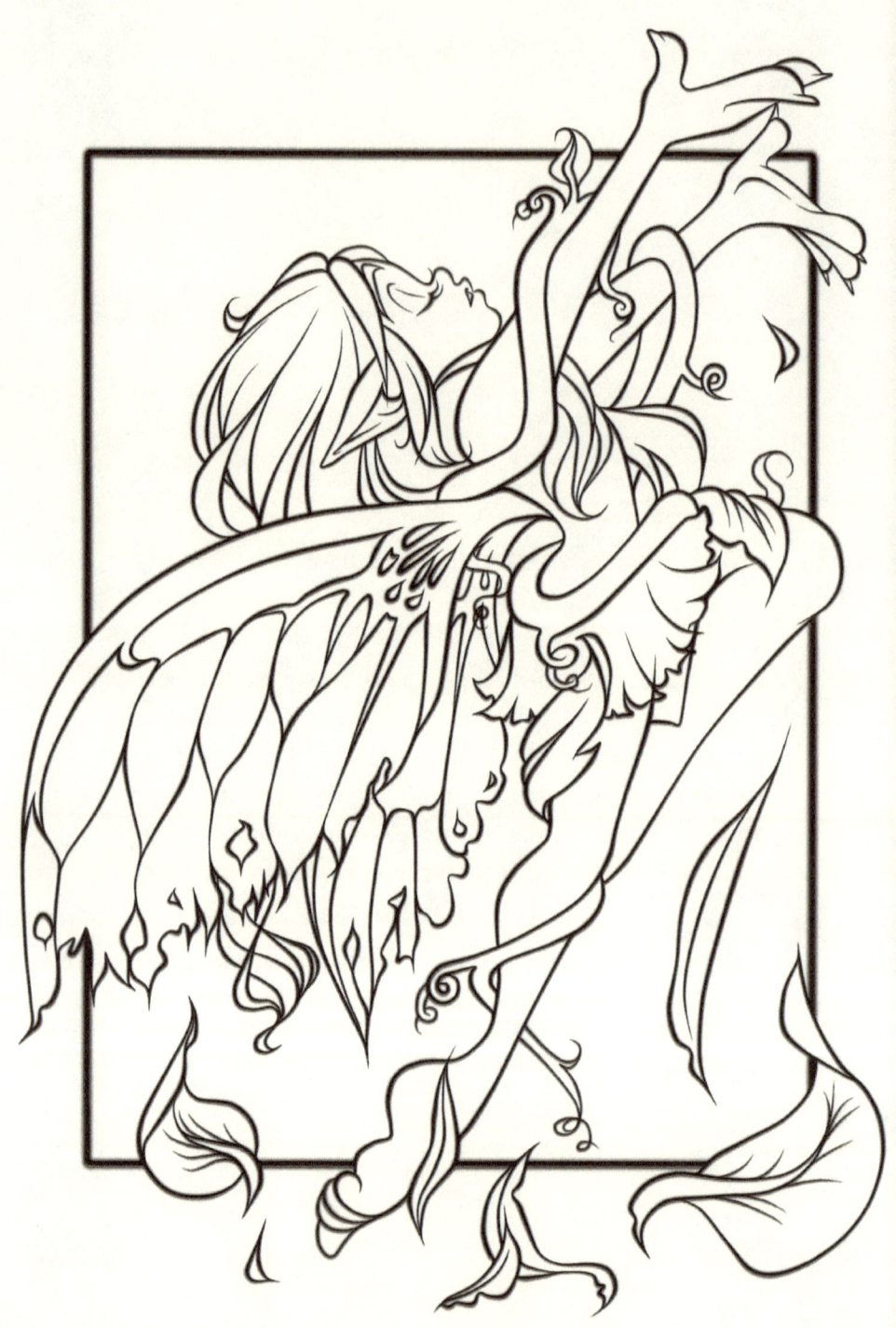

21

The Rain Fairy

Feel Everything

I shivered beneath the bramble, silencing my rushing thoughts with promises of letting them roam free once the journey was over. But their screams only grew louder, my chest grew heavier and my wings all but disintegrated. There was no end in sight to the storm all around and inside of me, so at last I grew tired of hiding and dashed into the open sky like a shooting star, letting the rain and emotions wash over me. That was the moment I found my light.

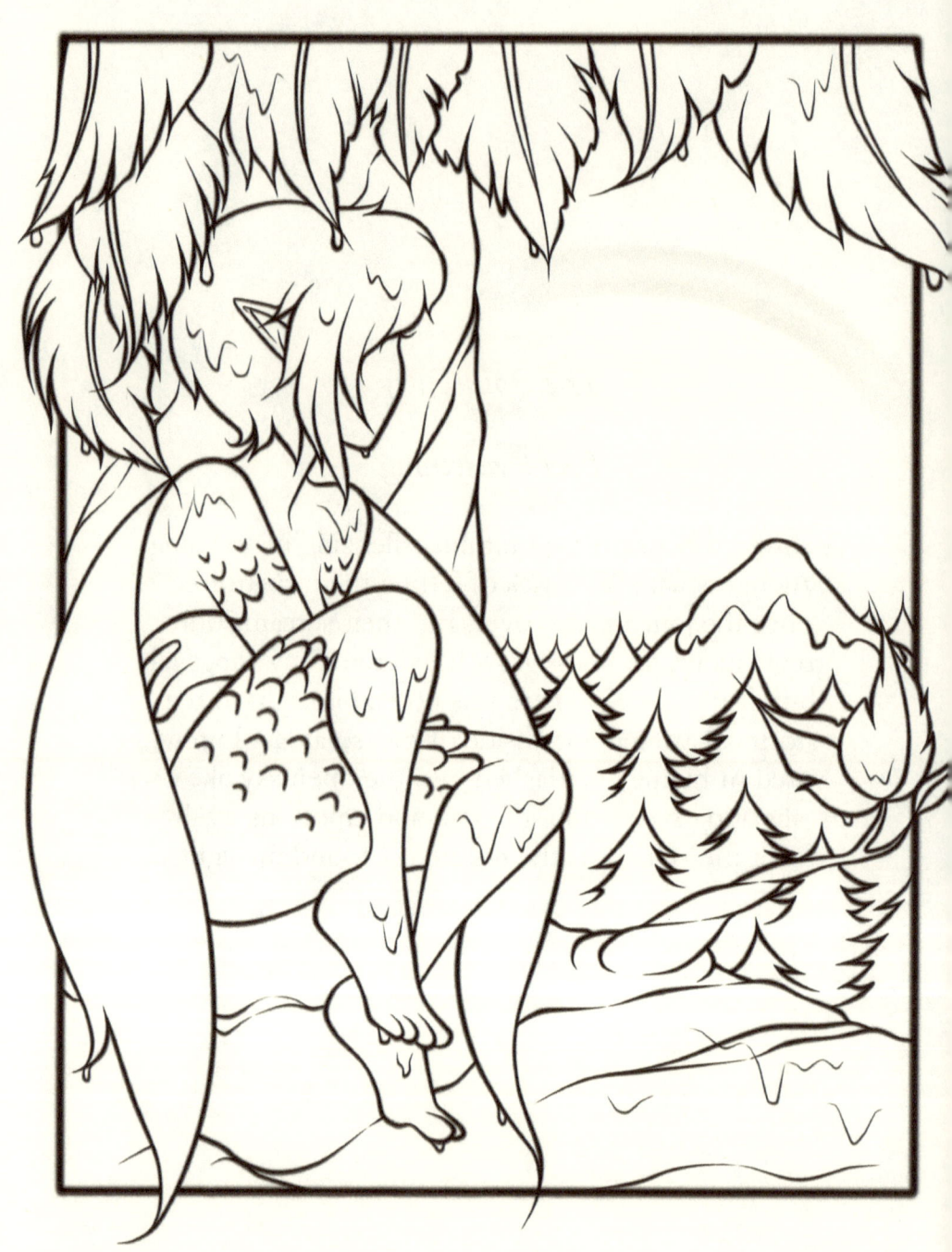

22

The Rainbow Fairy

Believe in Miracles

Doubt trickled into my mind as I wondered if my efforts would be enough. Then dread consumed my thoughts as I contemplated the possibility that this could all be futile, even after giving everything I had.
"It's only impossible if you give up," a rainbow called to me from afar, "Believing in miracles is what makes them happen."

The Raven Fairy

Grand Perspective

Too much focus on superficial imperfections distracted me from the crumbling whole, just as obsessing over my smallest flaws rendered me unaware of my deteriorating spirit. Too discouraged to fly, the raven lifted me to a place where I could see all the pieces well enough to put them back together. Distance makes the eyes grow sharper, the mind grow calmer, and the heart grow stronger.

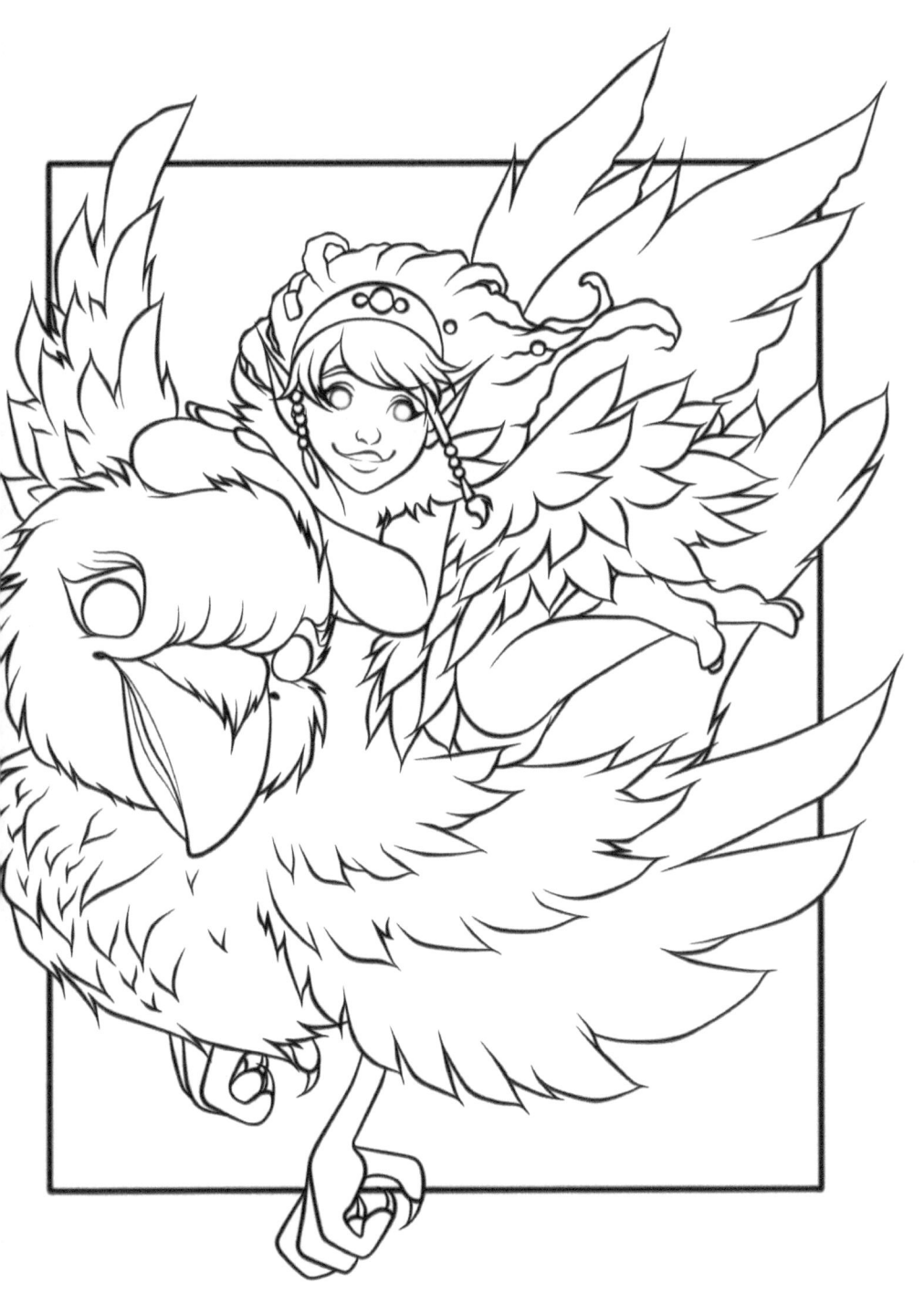

24

The Skunk Fairy

Self Love

Usually I can shrug off the misconceptions about me, but today I'm overcome with the unfairness of it all. "I know who you truly are," Skunk lifted my chin, knowing my plight all too well. "But most importantly, so do you." She wrapped her arms around me, forcing me to give my first genuine smile in a long time. "Being loved and appreciated begins with you. Others will follow your lead."

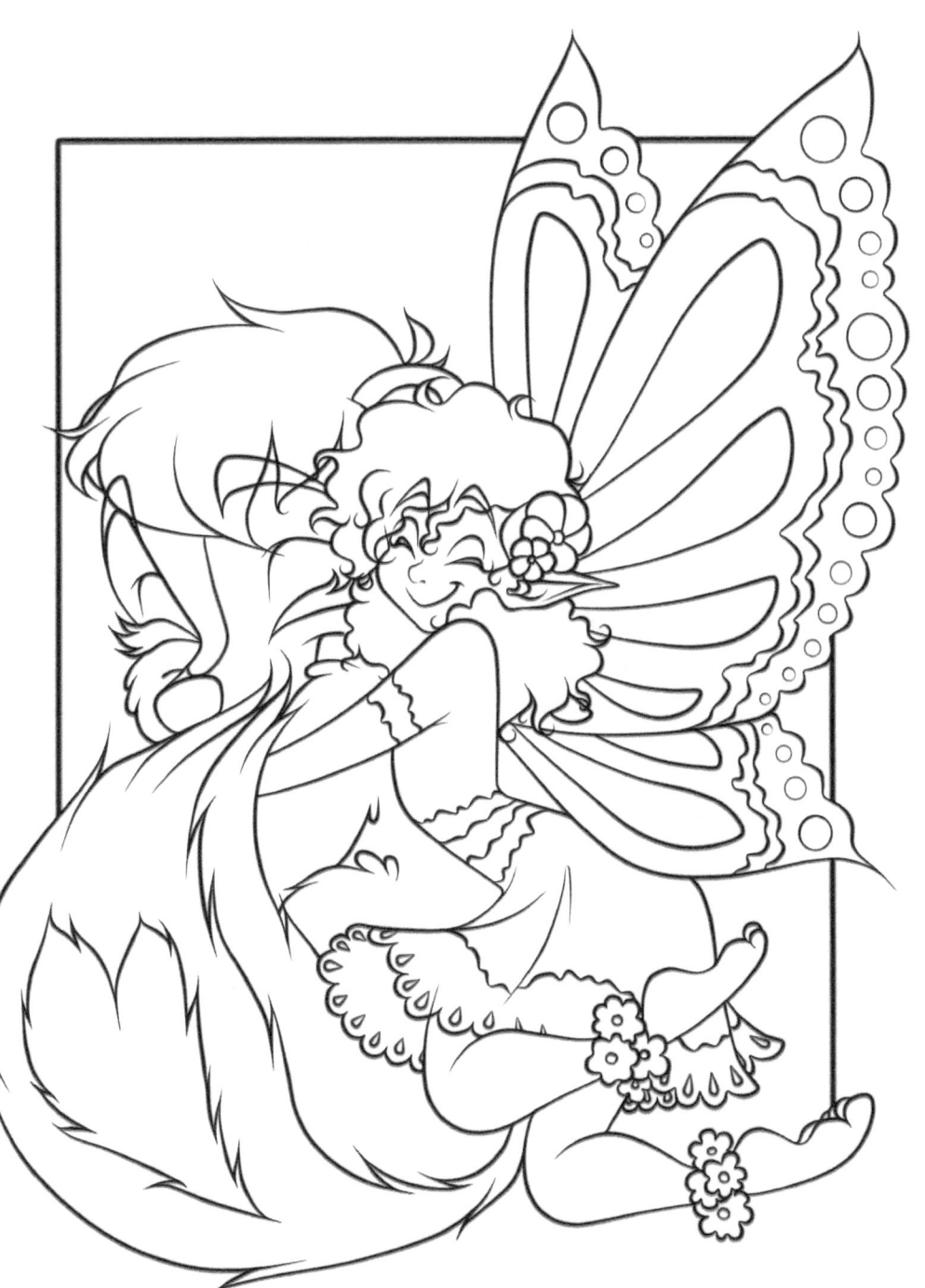

The Snake Fairy

Cleanse

I've striven, sacrificed, changed and overcome, so why did I still feel weighed down? "Though you've learned and accomplished much you're still clinging to your former identity," Snake said, "Shed your old desires, habits and beliefs so you may wear your new heart on your sleeve." Bit by bit, our exteriors detached from us slowly and painfully. When our new selves finally felt the warm sunlight we rejoiced to experience the greatest freedom we'd ever known.

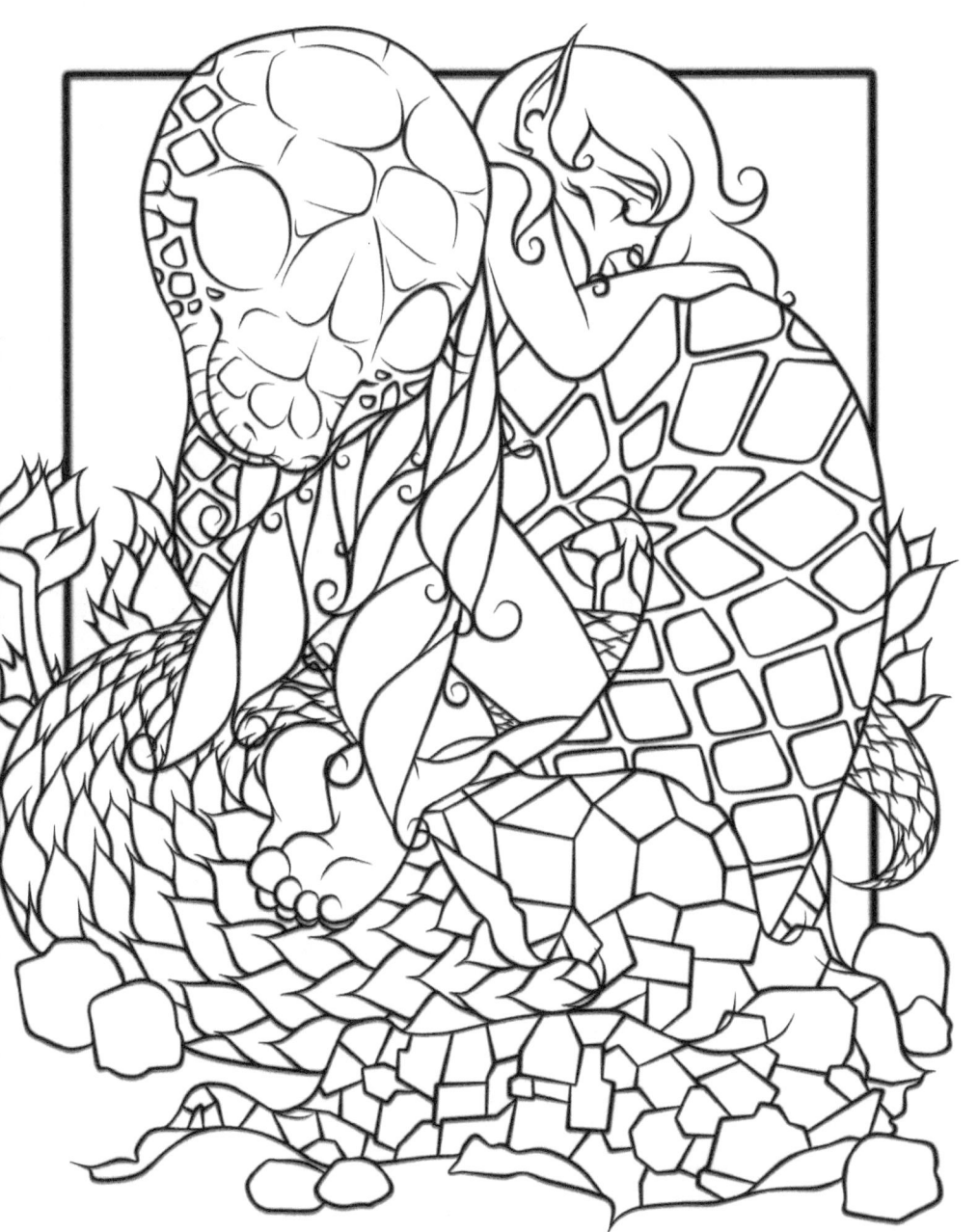

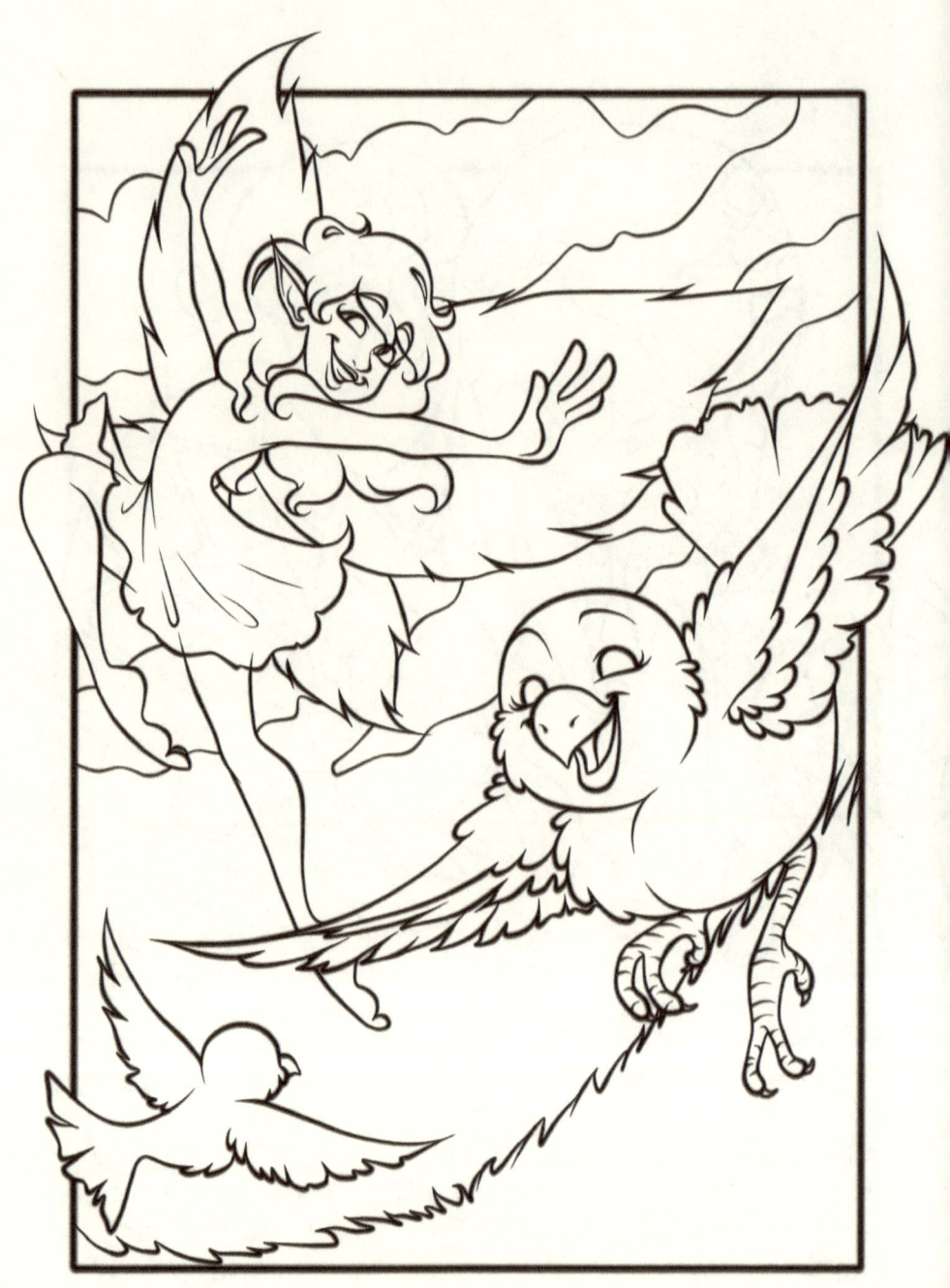

26

The Sparrow Fairy

Play

"I have no time for you," I said to the sparrows circling around me, distracting me from my long journey. However, I was also suddenly and pleasantly distracted from my troubled mind and heavy eyelids, so I shrugged and joined their dancing and singing. I immediately felt alive again, ready to show my challenges all I was capable of. I waved and smiled enthusiastically as the sparrows flew away, thanking them for reminding me of the joys of getting lost in a moment.

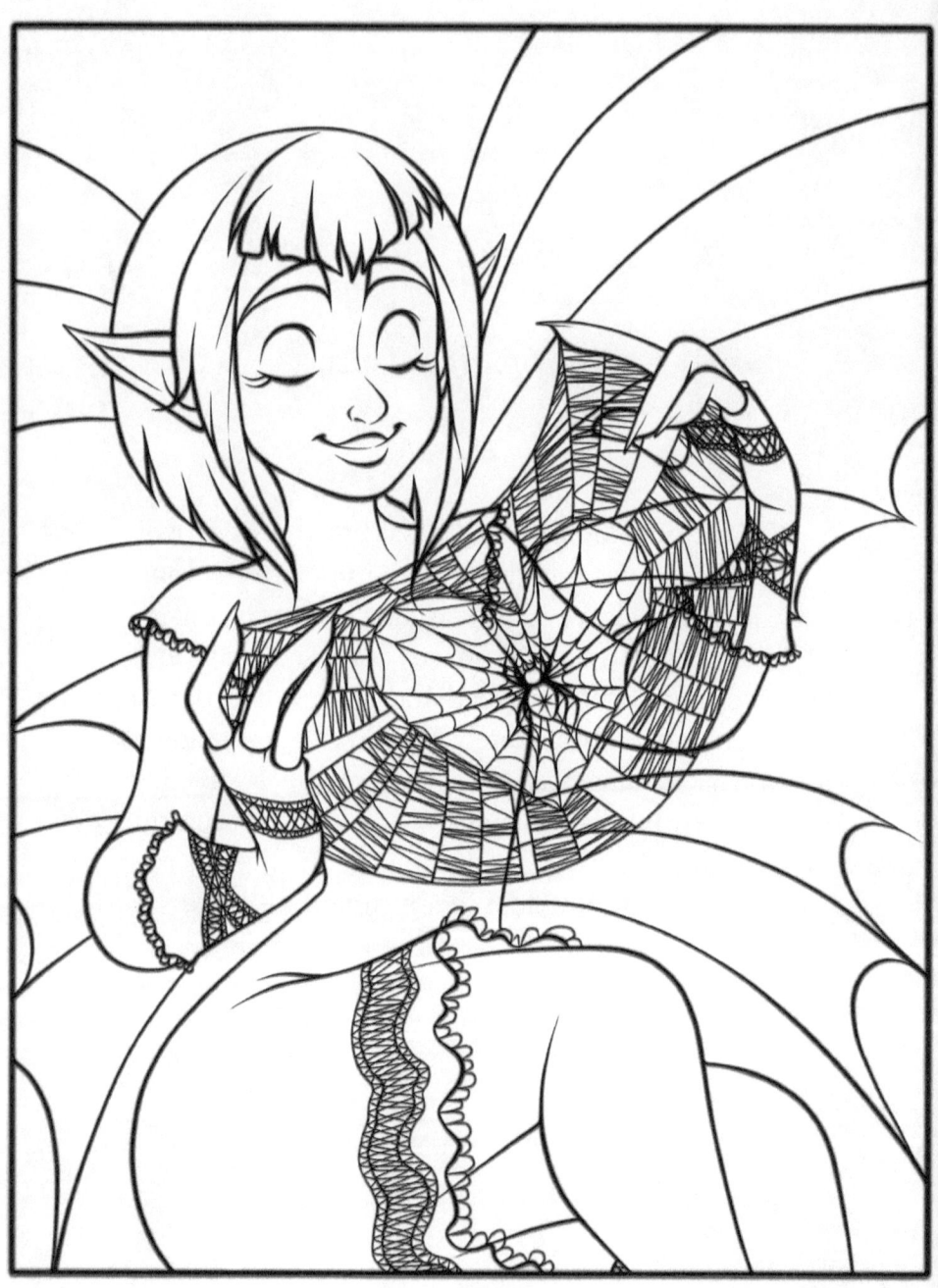

27

The Spider Fairy

Do What You Love

The once dewy silk strands fell upon the ground, destroyed and unappreciated, and yet the spider was already spinning a new web without a sigh or tear. I asked how her heart didn't crumble every time her beautiful creations were torn apart after putting her heart and soul into them. "Nothing mends my wounds better than doing what I love," she responded with a melody in her voice, happily consumed by her project. "Results are temporary, but experiences live within us forever."

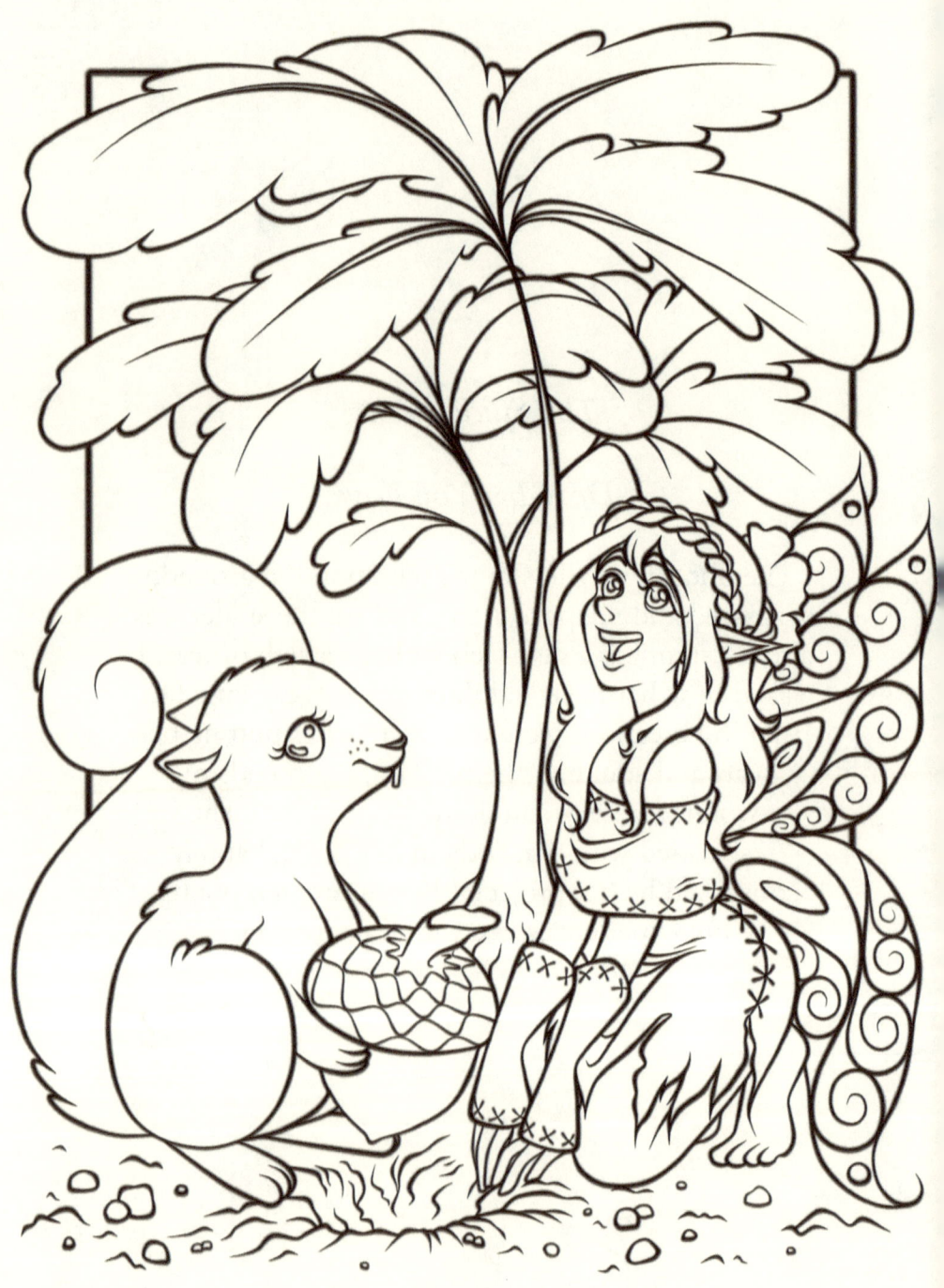

The Squirrel Fairy

You Are Enough

All my efforts to contribute to the world only left me worn, discouraged and wondering if I'll ever be able to make a difference. "Why are you trying so hard?" a squirrel asked as she patted her freshly-buried seed, one of many that will grow into the countless trees that exist simply because squirrels do what squirrels do best. "You make the world a better place every day just by being yourself."

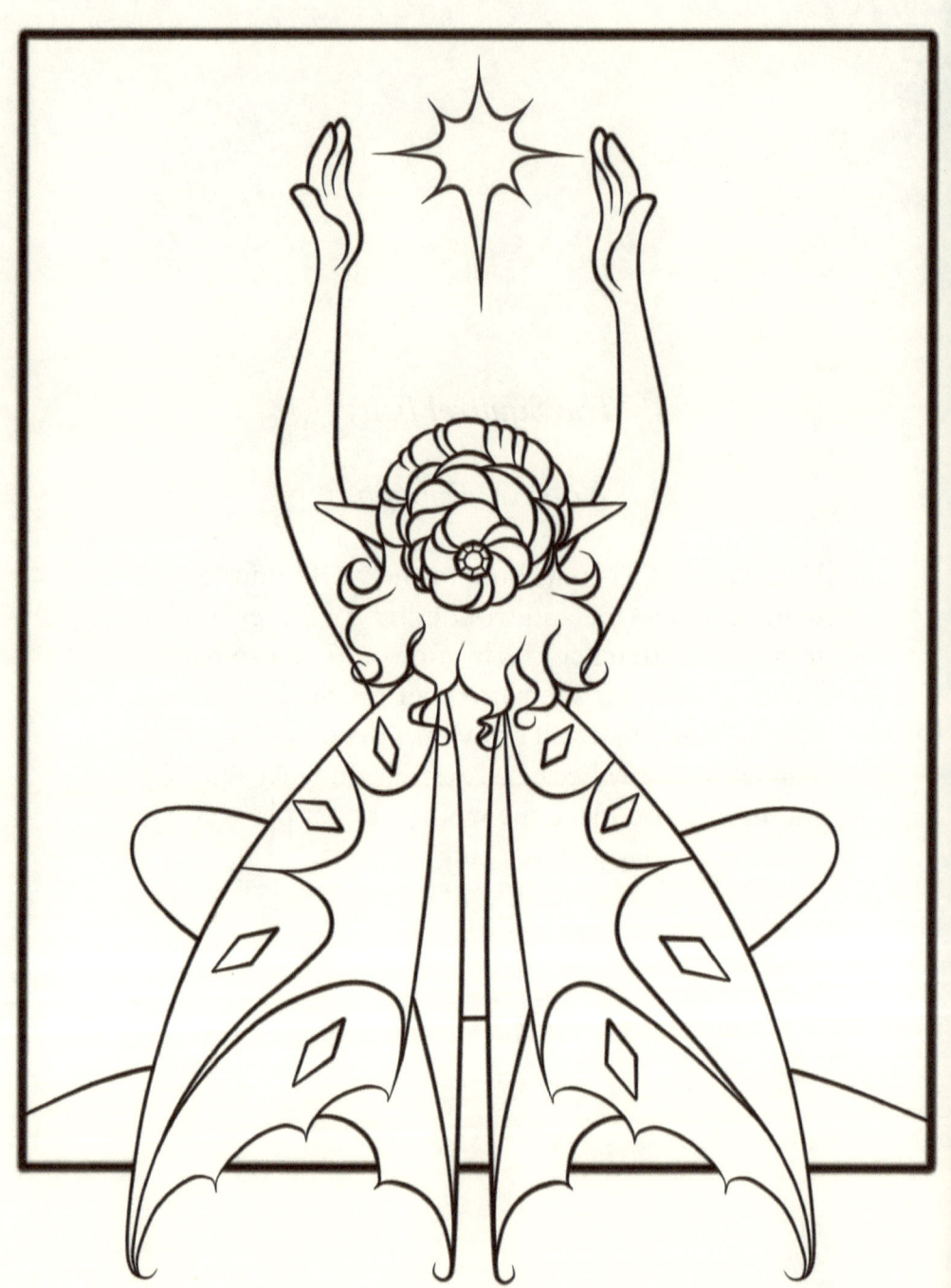

29

The Star Fairy

Hope

There was no reason to believe tomorrow would be better, but still I whispered my heart's desires to the night sky, determined to rise with the sun and continue on like the stars were realigning just for me.

The Sunshine Fairy

Compassion for All

In the dark silence I considered everything in this world that broke my heart, and it crossed my mind to only share my light with those I deemed worthy. But how can I only partially shine? I cannot determine where my rays fall, only if they exist to begin with. To withhold my light is to destroy my luminosity. I resolved to scatter beams of kindness wherever they fell as I gathered light to bring in the new day.

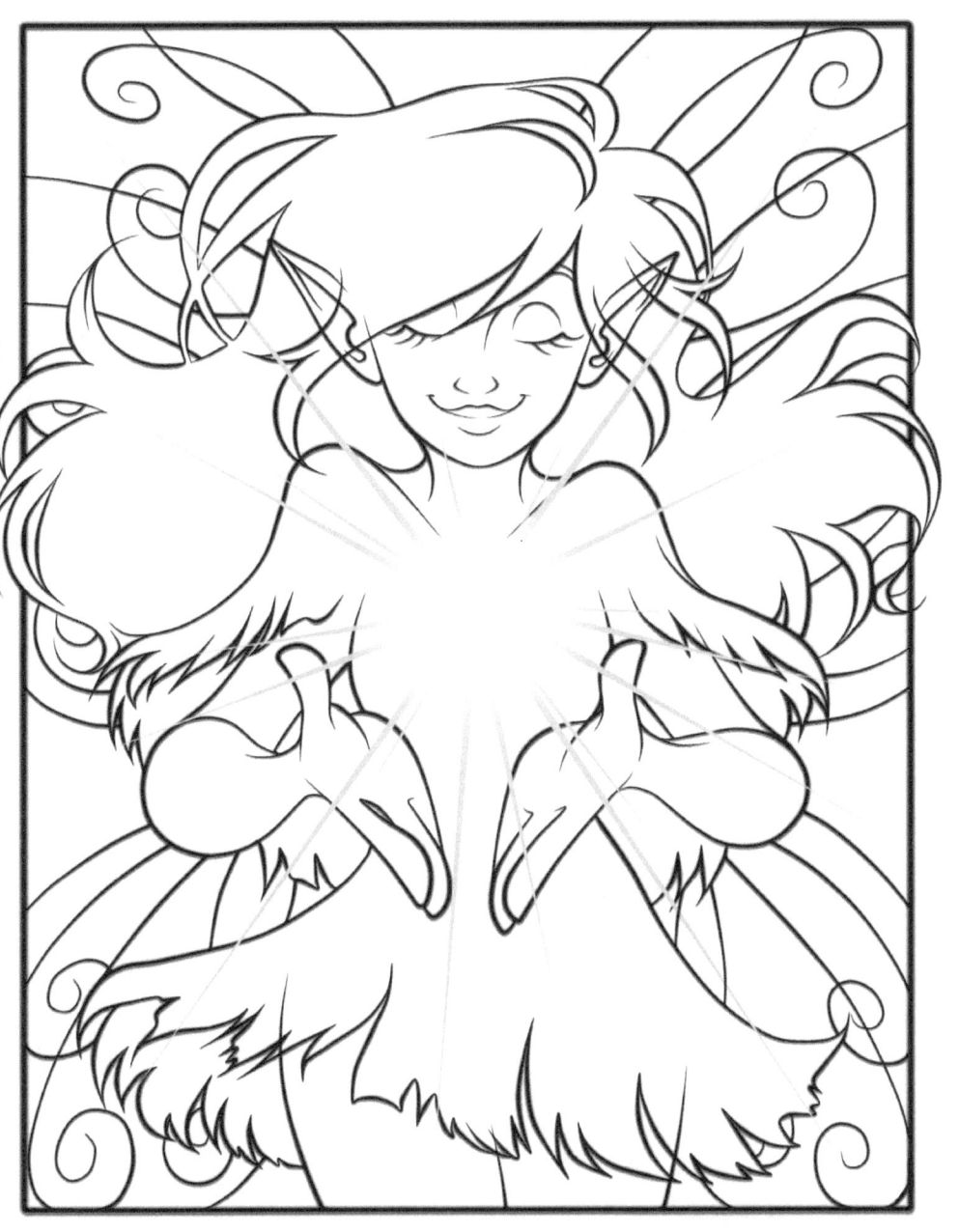

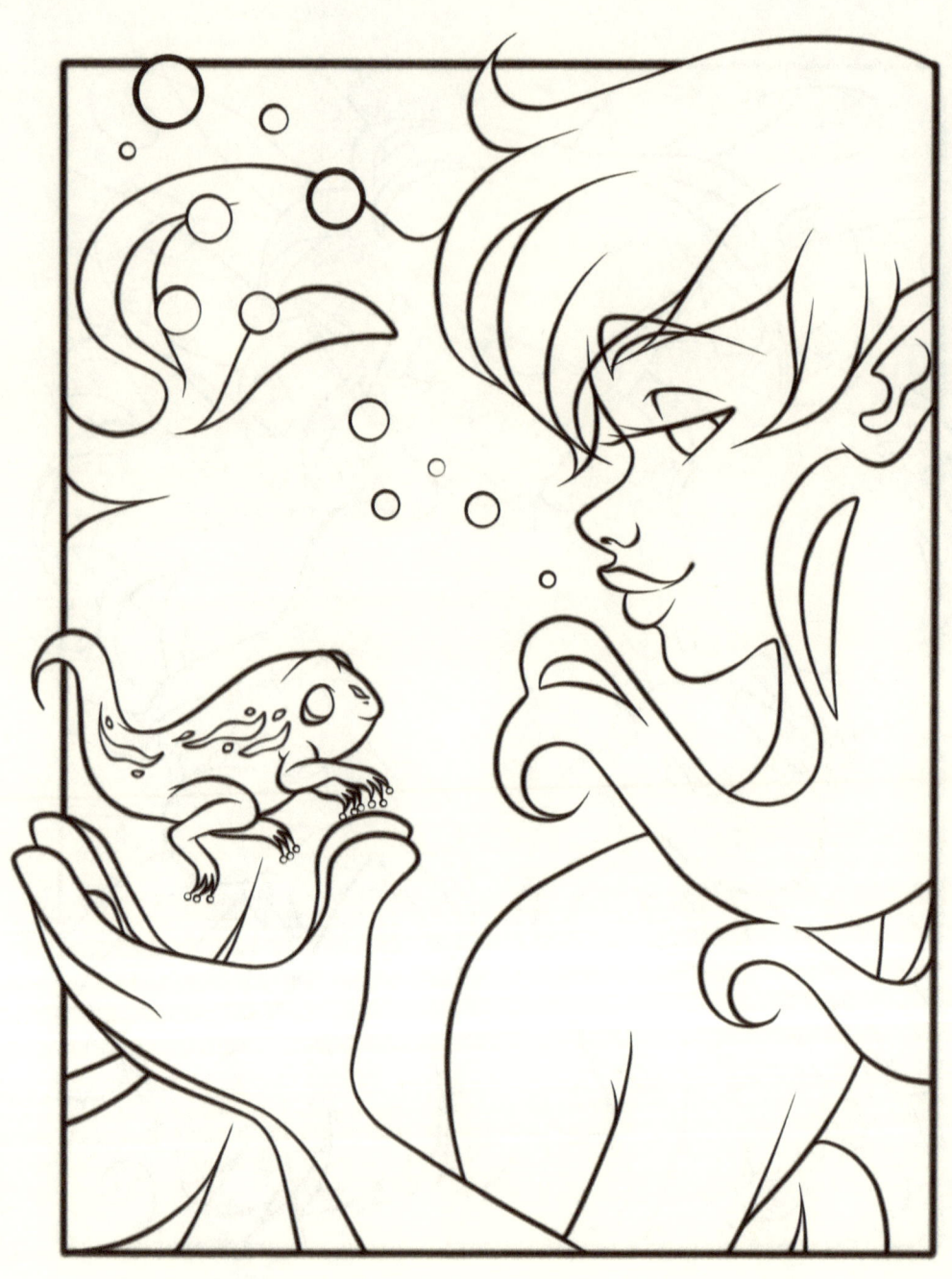

The Tadpole Fairy

Patience in Growing

"I'll like who I am once I've transformed into my Best Self," the tadpole sighed at his still-obvious tail. My heart bled for my beloved friend, "You are whole and wonderful just as you are. There's no such thing as being a Lesser Self," when a light inside of me said, "Yes, exactly. That goes for you too, even now as you strive for growth."

32

The Wind Fairy

Laugh

I'd never felt so small in all my life. My obstacles were towering, my thoughts swirling, my confidence fading, when a gust of wind flew by. I couldn't help but laugh at the surprise, and I found my dread shrinking to a harmless size. "Negative emotions magnify the darkness," the wind explained, "Laughing at what you fear is like wind pushing away the rain clouds so the sun can illuminate everything."

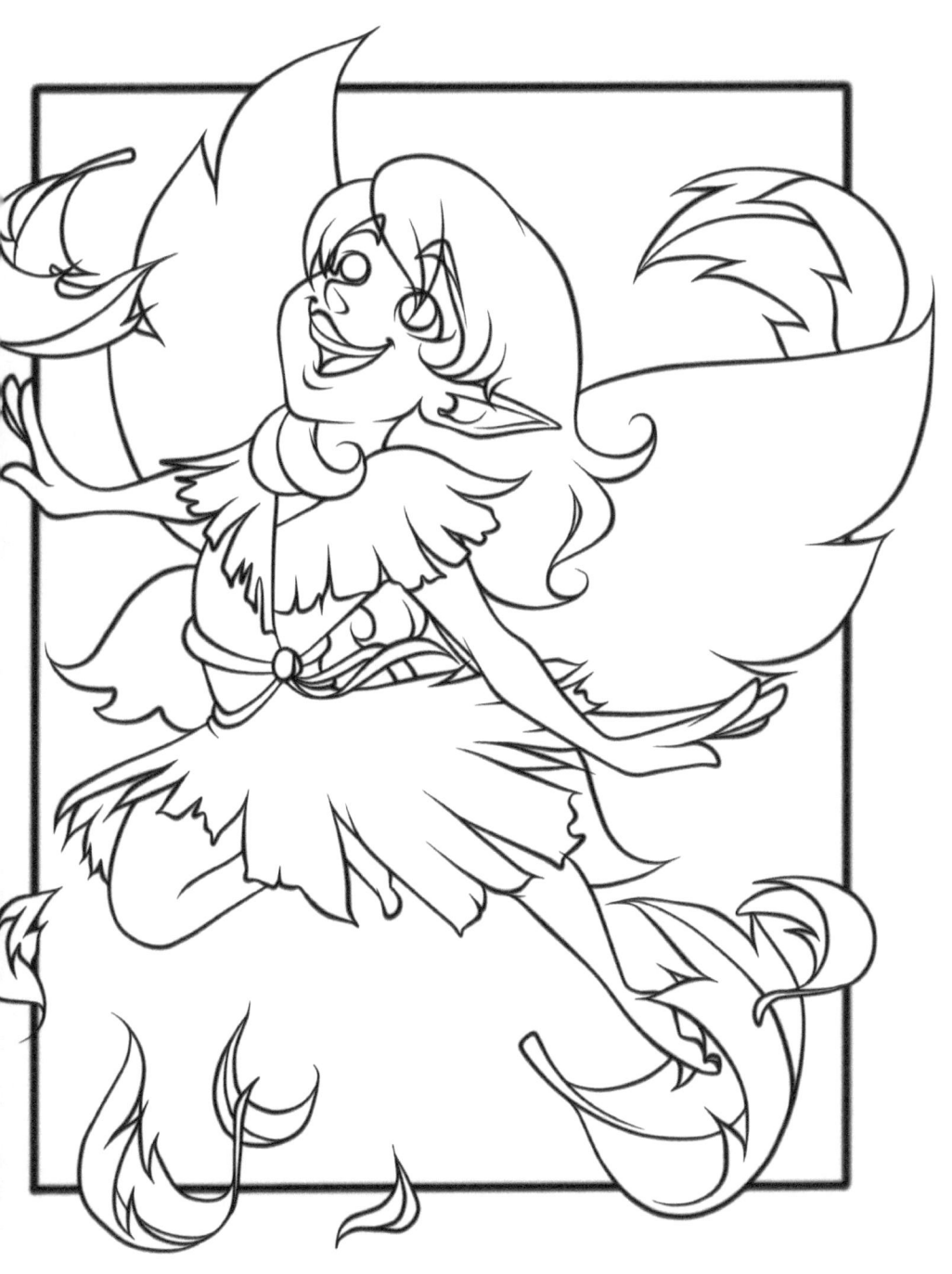

www.ingramcontent.com/pod-product-compliance
Lightning Source LLC
Chambersburg PA
CBHW021507210526
45463CB00002B/939